# a guide to extreme lighting conditions in digital photography

**duncan evans**

# contents

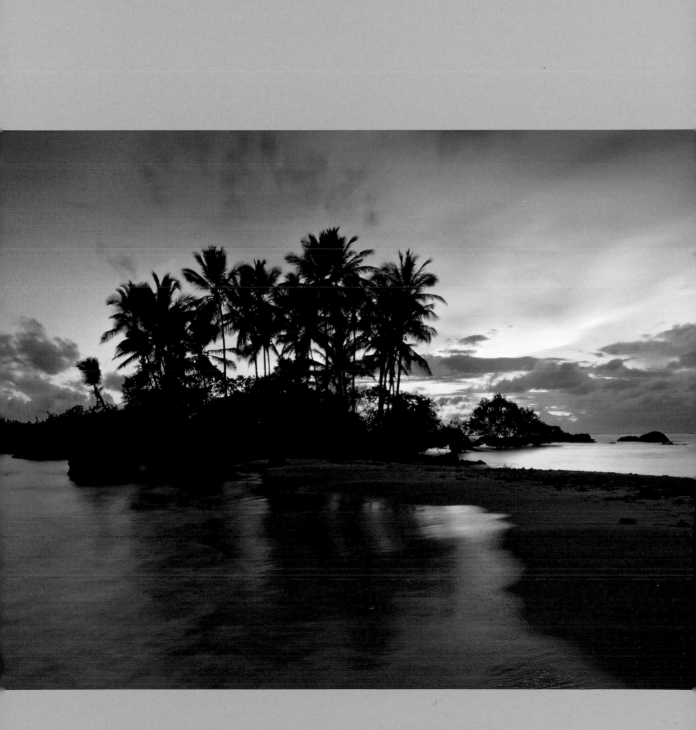

Magic Island by Marcio Cabral of Brazil, shot with a gold-blue polariser and a graduated ND3 hard edge filter.

# introduction

Welcome to the world of extreme lighting conditions in digital photography – whether it's the fiery glow of dawn; the retina-frying dazzle of the midday sun causing havoc with impossible contrast; an apocalyptic sunset; or the ethereal world of twilight photography. These are the lighting conditions that photographers either seek out and fail to master, or are confronted with and defeated by. This book is where the fight back against difficult, tricky and downright impossible lighting situations begins. It covers the two extremes of lighting conditions – the very dark and the very bright – and will help you capture the picture you want, digitally.

First, let's discuss definitions. Extreme lighting includes low-light photography, which covers conditions both indoors and outdoors. It could mean taking photographs using window light, tungsten, candles and firelight. Outside, it means shooting images at dawn, dusk or night-time.

At the other end of the spectrum is high-contrast lighting, which usually occurs outdoors when the sun beats down at midday creating reflections, burn-out and a tonal range that is impossible for the camera to capture.

This book starts off by explaining what you need and what you can get away with. Discover what you need to have in your kit bag the next time you step outside. We'll discuss cameras, hardware, and other issues including: camera modes specifically designed to tackle digital noise from long exposures and essential filters that are crucial not only to film photography, but digital as well.

We then get shooting with dawn's early light. As daybreak approaches, the light changes and lends the scene a magical air. Take advantage of the light to capture fantastic landscape and seascape shots, plus buildings and misty, atmospheric images. As the sun rises, cold air and water heat up, forming early morning mist. Shoot through this for an ethereal effect.

We then move on to midday and those impossible lighting conditions where the sun blazes and everything is rendered as a silhouette. Read on and discover how to keep detail in sparkling seas, pristine snow falls, cities with highly reflective surfaces, and all the places outdoors where very bright light would otherwise make photography impossible.

As dusk falls, late evening light takes on a golden hue. Use this to show buildings or landscapes with sharply defined shadows, set against brilliant blue skies. After the sun has set, clouds are immediately lit up in the sky. With your camera, face where the light is coming from for the most dramatic type of landscape photography. From golden clouds to apocalyptic reds, this is the sky putting on a performance for your lens.

When the pyrotechnics finish, the sky takes on a deep blue colour and ambient lights can then be recorded from cars, buildings and external light sources. We next cover cities, fireworks, watery reflections, fairgrounds and campfires at night.

*A Guide to Extreme Lighting Conditions in Digital Photography* isn't just about roaming the landscape.

There are numerous topics to tackle indoors as well. These include low-light portraits; high-contrast backgrounds; high key images; throwing people into silhouette; or deliberately using limited tonal ranges to white-out backgrounds. When taking photographs indoors, it's all about recording the ambient light rather than using flash (which has the tendency to kill the atmosphere). However, low levels of ambient light throw up problems of slow shutter speeds and camera shake. Solve these shooting problems with the various examples provided – from wedding receptions to music gigs.

Just because it's nearly dark doesn't mean you can't capture movement; but how you portray it can vary as the examples on car trails, waterfalls and people demonstrate. Everyone likes a slow-motion waterfall shot, but to get the long shutter speed required, you need to use filters to decrease the light coming into the camera. The techniques and requirements are fully explained in this book. If you want to get truly creative, then try painting with flash or torchlight. This skill is a tricky one to master, but pays dividends when it all comes together.

Perhaps the most subtle form of low-level lighting is candlelight. This gives off a flickering, warm light that requires long exposures, a tripod and the subject (if a person is involved) to keep very still. Candlelight is useful for still-life shots – where you want a warm colour cast – to nudes, where a feeling of intimacy is required. How you deal with colour cast depends on the overall effect desired. It can be tackled either

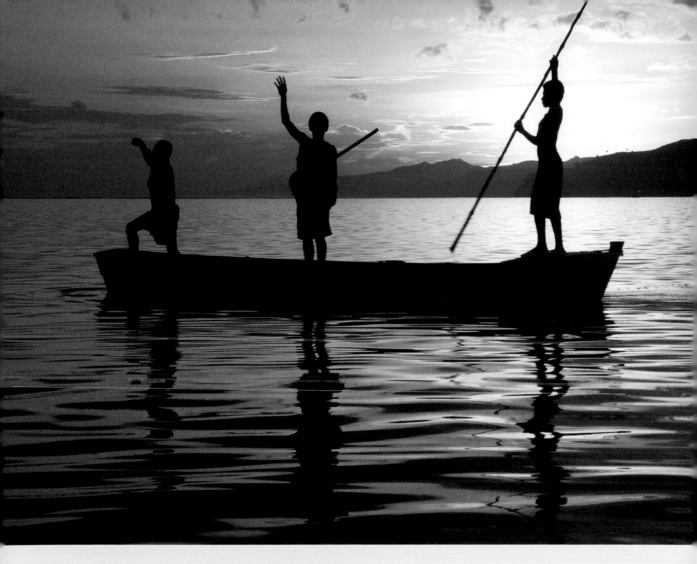

fully or partially in-camera, but also with computer software later.

The final chapter deals with digital trickery: from combining different lighting sources to turning day into night; converting colour images to black and white; capturing star trails; and tackling the bane of digital cameras – digital noise from long exposures.

Whatever aspect of photography you are interested in, there's a fair chance that at some point you'll either want to take on low-light conditions or be faced with fiercely bright ones. The aim of *A Guide to Extreme Lighting*

*Conditions in Digital Photography* is to show you how images like these can be captured and enhanced so that you too can make magic when low light levels beckon or high contrast threatens.

Duncan Evans LRPS

The Spear Fishers by Juergen Kollmorgen, taken at sunset.

images

The images in this book feature dramatic photographs taken under extreme lighting conditions, both indoors and outdoors.

# how to get the most out of this book

This book is divided into 11 chapters. The first chapter discusses camera modes and capabilities, and how to choose the right gear and filters. The subsequent chapters each cover aspects of extreme lighting conditions in digital photography such as shooting images in dawn's early light; shimmering landscapes; sunset conditions and later; photographing in dark places; capturing movement; contrast; light painting; and shooting images using candlelight or tungsten glow. The final chapter covers special digital processes such as correcting white balance and cleaning up digital noise. The appendix includes a useful glossary of technical terms, together with photographers' biographical details.

Each spread is self-contained and explains either how specific images have been created in depth, or gives a brief overview of the important steps to accompany a detailed look at a particular technique or feature. Helpful quotes from the photographer or author put a personal slant on the information presented. Everything is explained from the photographers' hands-on point of view, not just from a theoretical approach. The design allows you to dip into the book at any stage to gain useful insight, without necessarily having to read the chapters and spreads in order.

The featured work comes from both professional photographers and talented enthusiasts, and there is something for everyone, no matter what their approach or starting point.

**introduction**

An overview of the theme and techniques set out in the spread.

**flow chart**

A step-by-step outline of the main stages that the image has gone through is given in a flow chart. This allows a quick reference to the same or similar points of interest on different spreads. The flow chart also enables the reader to determine at a glance how simple or complex an image was to create.

> digital capture
> straighten image
> warmth/brilliance plug-in filter
> skylight plug-in filter
> brightness/contrast
> unsharp mask

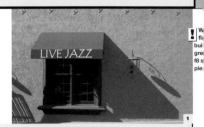

LIVE JAZZ

! W
fla
bui
gre
f8 s
ple

1

## patterns and shadows

As the sun beats down at midday or early afternoon, it can make landscape photography exceedingly difficult. However, if you are in a town, why not turn your camera away from the sky and search out the shadows on buildings? If you can find attractively coloured walls, the sun will make them vivid as digital tends to prosper in strong light, where it isn't aimed directly at the camera. Look for shapes, patterns and interesting shops and buildings.

### shoot

The coastal southern California city of Ventura, USA, has a charming downtown with shops and restaurants. When Patricia Marroquin of Oxnard, California, visits, she parks next to Café Fiore, an Italian restaurant. The side of the building has several windows with overhangs bearing various signs: Live Jazz, Cocktails and Pizzeria. Patricia was passing one afternoon and noticed the interesting shadows in the harsh afternoon light. She captured the image with a Canon digital SLR using a Sigma 28–300mm superzoom lens.

! You should look for shapes that shadows form on the buildings. The best ones to capture are either very ornate ones or those that don't resemble the structure from which they are cast because of the angle of the sun.

### enhance

The original image was s askew so the first task w to straighten it using the semi-automatic Straight option in Photoshop Ele

The contrast and warmt image was increased th use of a plug-in filter call Efex Pro (3).

Another filter in the sam package (Skylight) was reduce the haze effect o ultraviolet light in the sc

3  **brilliance/warmth**

Brilliance ............................ 136
Warmth ............................... 108

**Save Load Help**

4  **skylight filter**

Strength ................................ 8

**Save Load Help**

34  **shimmering landscapes – patterns and shadows**

section and spread title

## tips

Practical tips from the author and photographer allow the reader to apply issues raised in the images discussed to their own creative work.

## shoot – enhance – enjoy

Where possible each spread is divided into the sections 'shoot', 'enhance' and 'enjoy'. 'Shoot' explains the background details up until the moment of capture. The choice of equipment and the context of the shoot are revealed. The 'enhance' section explains the process that the image has been through once in computer, outlining the stunning results that the digital photographer can create post-capture. The 'enjoy' section reveals how the image has been used for personal enjoyment or professional use, and the output method.

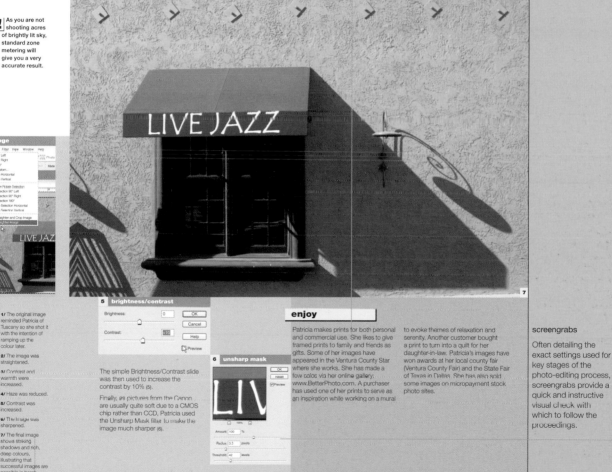

! As you are not shooting acres of brightly lit sky, standard zone metering will give you a very accurate result.

**straighten image**

1/ The original image reminded Patricia of Tuscany so she shot it with the intention of ramping up the colour later.

2/ The image was straightened.

3/ Contrast and warmth were increased.

4/ Haze was reduced.

5/ Contrast was increased.

6/ The image was sharpened.

7/ The final image shows striking shadows and rich, deep colours, illustrating that successful images are possible in harsh lighting conditions.

**5 brightness/contrast**

Brightness: 0

Contrast: +10

The simple Brightness/Contrast slide was then used to increase the contrast by 10% (5).

Finally, as pictures from the Canon are usually quite soft due to a CMOS chip rather than CCD, Patricia used the Unsharp Mask filter to make the image much sharper (6).

**6 unsharp mask**

Amount: 100 %
Radius: 3.5 pixels
Threshold: 42 levels

### enjoy

Patricia makes prints for both personal and commercial use. She likes to give framed prints to family and friends as gifts. Some of her images have appeared in the Ventura County Star where she works. She has made a few sales via her online gallery: www.BetterPhoto.com. A purchaser has used one of her prints to serve as an inspiration while working on a mural to evoke themes of relaxation and serenity. Another customer bought a print to turn into a quilt for her daughter-in-law. Patricia's images have won awards at her local county fair (Ventura County Fair) and the State Fair of Texas in Dallas. She has also sold some images on micropayment stock photo sites.

## screengrabs

Often detailing the exact settings used for key stages of the photo-editing process, screengrabs provide a quick and instructive visual check with which to follow the proceedings.

## captions

The image captions clarify and recap the processes shown in each image.

# 1  gear guide

Extreme lighting conditions are very demanding so it makes sense to know what kind of camera gear and filters you will need for the various situations that are discussed in this book. This short chapter explains the advantages and disadvantages of different types of digital cameras and the capabilities needed to succeed in the world of extreme light.

This image by Deryk Baumgaertner of the New York docks and skyline was shot with a digital SLR. It shows the use of a tobacco graduated colour filter to tone a long exposure image.

Deryk says, 'I love the night and long exposure photographs, and often use grey, tobacco and mauve graduated filters to enhance the colours.'

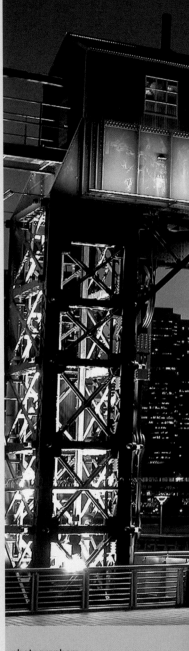

**photographers**

Deryk Baumgaertner
Steven Rosen

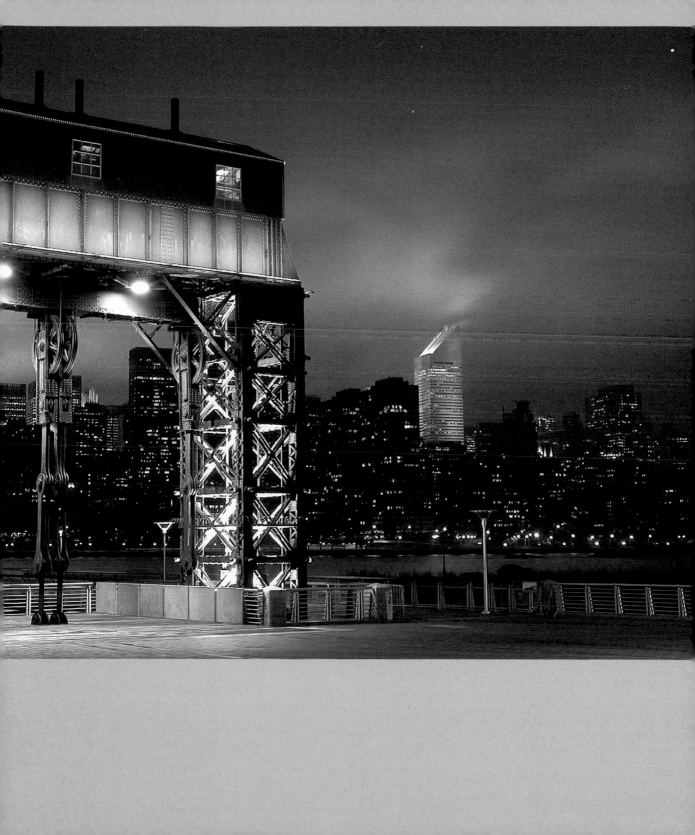

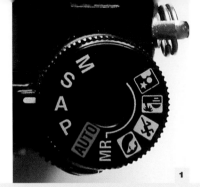

# camera capabilities

When faced with extreme lighting conditions, from dark and gloomy to fierce and bright, it's reassuring to know that your camera is going to cope with the situation. There's no use firing away in automatic programme mode and hoping that the camera will sort out either. You have to know how to shoot the situation and what settings to use on the camera.

So, are we demanding an all-singing, all-dancing digital SLR then? Well, not quite, but extreme lighting conditions do require specific abilities and if your camera doesn't offer the power and flexibility, then you need to think about how to get around the limitations.

For low-light photography we are invariably talking about long exposures. A point-and-shoot camera with no creative control is completely useless here, even if you do manage to turn the flash off. Your camera needs to have a full set of programme modes, from aperture priority to manual. Aperture priority is the most useful programme mode of all – you can set the aperture to give the creative effect you are looking for and the camera will supply the appropriate shutter speed. When setting up a low-light shot while shooting landscapes, then you want maximum depth of field. That means using the smallest aperture, or the highest f-stop number on the camera. On an SLR this is typically f22, but on a digital compact it's only f8. This isn't as bad as you might think because a compact uses a smaller CCD/CMOS chip and a shorter focal length in a smaller lens. The result is up to five times more depth of field at the same aperture than on a film SLR camera. However, due to the limitations of the lens and the sensor size, the detail won't be as good as the same picture shot at f22 on an SLR.

When using narrow apertures in low-light conditions, the shutter speed will invariably be a long one. This means the camera must have a screw thread on the bottom for a tripod. All SLRs have one, but the cheaper compacts might not. There are limitations to the aperture priority metering mode, and using f22 on an SLR will push it to the limits. It could often be necessary to do some mathematics and switch to manual mode because the shutter speed can normally be set longer, or to Bulb. Bulb is the mode where the user controls how long the exposure lasts.

A consequence of long exposures is that digital noise becomes more evident. This isn't the multicoloured splatter that comes from using a high ISO rating, it's more bands and blocks of colour aberration – often green – in the shadow areas of the image. If your camera has a long exposure Noise Reduction mode (and many compacts and SLRs offer this), then learn how to use it as it will help render a noise-free image. Also, be aware that the longer you use the digital camera in a session, the warmer the CCD gets; in long exposures, this means more noise.

## bright young things

At the other end of the spectrum we have blinding, bright light and extreme contrasts. Often, you want to shoot portraits and use a wide-open aperture to throw the background out of focus. Even if the background isn't brighter than the subject, at midday, it's often so bright (particularly if the subject is in the sun), that the required shutter speed may exceed the fastest the camera can handle. Many compacts can only shoot up to 1/1000th of a sec, which on a very bright day or in backlit conditions, at f2.8 isn't fast enough. In fact, because compacts produce so much more depth of field, you really need to shoot with the aperture as wide as possible. Digital SLRs tend

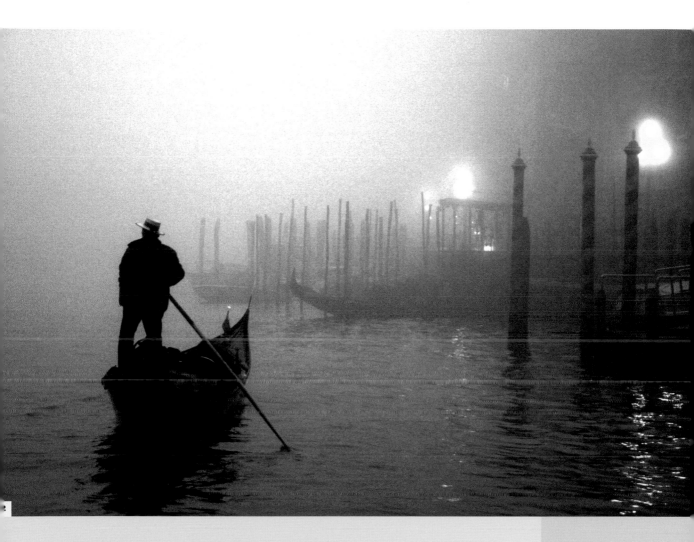

to be better specified, but certainly check the statistics for a camera before purchase. If you are using a portrait lens that offers f1.8 and are shooting a subject backlit by the sun, you're looking at needing a shutter speed of around 1/4000th of a sec. Now that's fast!

One thing that can help is using a neutral density filter. This reduces the light coming into the camera and it usually comes in the form of a square piece of plastic or glass. To attach it to your camera you need a filter holder and this attaches to the lens by means of a lens thread. Your camera will either need to use interchangeable

lenses, like an SLR, where there is a thread on each lens or your compact camera will need to have a thread system so that you can use filter accessories. If your compact is not equipped with a thread system, it is seriously handicapped in extreme lighting conditions, even if it has a good selection of programme modes.

> **!** If you look at a film photographer's kit bag, it can be stuffed full of filters, many of them entirely useless. However, there is a key set that every digital devotee should not be without. They can make the difference between a great image or a failed photograph.

# essential filters

There is a certain mindset in the digital camera community that just because you can work wonders with Photoshop, you don't need to bother with filters. This is, of course, nonsense. Digital has a limited tonal latitude, just like slide film, which means that you can never capture the full range of tones in a scene with lots of contrast. Extreme lighting almost guarantees extreme contrast, so filters are absolutely essential to great photography in challenging conditions.

## neutral density filters

The neutral density (ND) filter is a square piece of either plastic or glass. It fits into a filter holder that screws on to the front of the lens. The filter contains a uniform shade of grey that serves no purpose other than to reduce the amount of light coming into the camera. There are usually various strengths, rated according to how many aperture stops of light they prevent getting through to the camera. The basic ND filter is used when you specifically want to lower the light level, whether to use a wide open aperture for minimal depth of field or to generate a long exposure for creative effect.

It's worth having an ND2, ND4 and ND8 filter in your bag, but there is another variety that is just as valuable for digital, if not more so. That's the graduated ND. This is an ND filter at the top that fades to clear at the bottom. If it goes sharply from completely grey to completely white, then it's known as a hard grad; if it goes over a longer spread it is known as a soft grad. The hard grad is useful for photographing a flat horizon such as a seascape, the soft one for when the horizon is more uneven. The graduated ND filter can

be used to balance exposures where there is a bright sky or a very reflective landscape element. If shooting at dawn or sunset, when sunlight is in the sky, it is essential to be able to control the exposure so that landscape and sky are both recorded. The alternative is that by recording the sky faithfully, the ground is rendered as a silhouette.

## the polariser

This is a circular filter that rotates within the filter holder. It has two purposes, both of which affect how light is recorded by the camera. First, it makes colours deeper. On film, this works very well, but on digital, it makes colours darker instead of stronger. Secondly, it can cut out reflections, whether they are from water, glass, steel or any other reflective surface. The actual

application of this is to rotate the filter until either it stops all reflections so that you can see through it, or rotate it in the opposite direction so that all you get are reflections. This is very handy if there is a spectacular sky that can be reflected fully in the water. Be warned though, the polariser filter can reduce light coming into the camera by between one and two stops.

**1/** A graduated filter.

**2/** This shot by Deryk Baumgaertner of Cologne, Germany, is called Moon over Mont Saint Michel. It shows the use of a polariser to ensure that reflections are recorded.

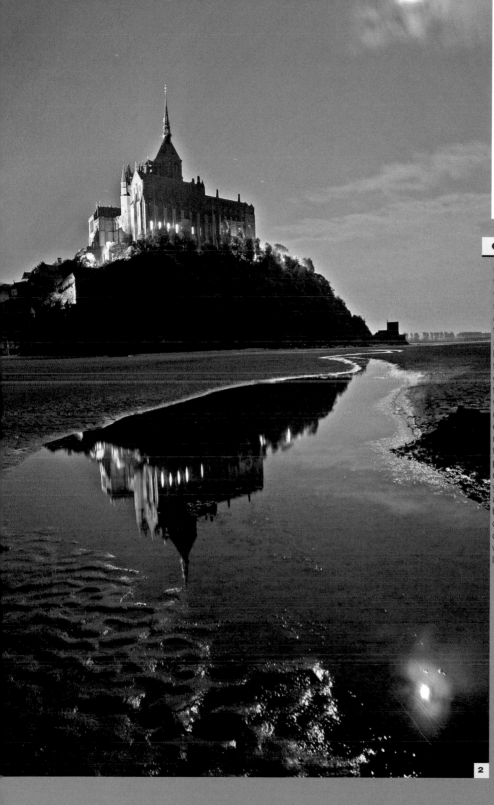

## coloured filters

Caution needs to be exercised here for the simple reason that the automatic white balance on a digital camera will see any colour cast as a function of the ambient light, and attempt to convert it to pure white. When using a colour filter, you will need to set the white balance manually and accurately for the filter to work properly. When it does, you can add red-orange filters for sunsets, warm sepia colours to warm up the picture, tobacco filters for distinct brown toning and others to enhance the general colours. The reason for enhancing certain colours at this stage rather than the post-production stage is not to replace the digital process, but to make it easier. If you have to significantly shift colours around in Photoshop, the image will become progressively noisier, hence degrading the quality. If the basic colour has been enhanced to start with, it may need nothing more than a little tweak in post-production.

2

# 2 dawn's early light

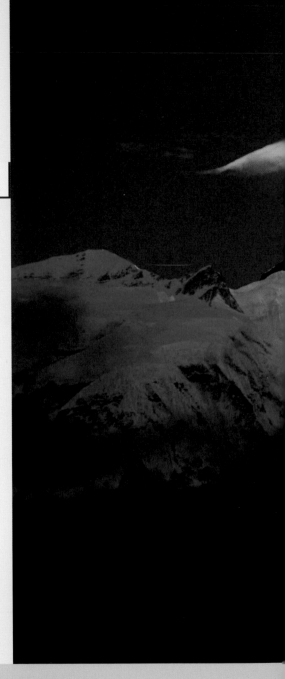

There are two phases to sunrise: just before the sun comes up, when there is colour and light in the sky, but the ground is dark; and then when the sun crawls above the horizon. The contrast between light and dark is too large for the unaided camera and poses a great challenge to the photographer.

Martin Wierzbicki of San Francisco, California, USA shot this photo in Nepal with a Canon camera and a 28–135mm f3.5 zoom lens – just as the sun was rising.

Martin says, 'After a fitful night of little sleep at 16,000 feet, I woke at 5am to climb Gokyo Ri, a nearby mountain known for its expansive views of Everest and the high Himalayas. I stepped outside to a frosty clear morning and a dark cobalt sky. The icy peak of Cho Oyu towered two miles above. As the first rays of the sun lit up the peak, a long thin cloud floated across the summit, and I knew there wouldn't be many mornings in my life like this.'

## photographers

Martin Wierzbicki
Dirck DuFlon
Wayne Willis
Chris Spracklen

Jon Bower
Peter Anderson
Marcio Cabral
Roger Tan

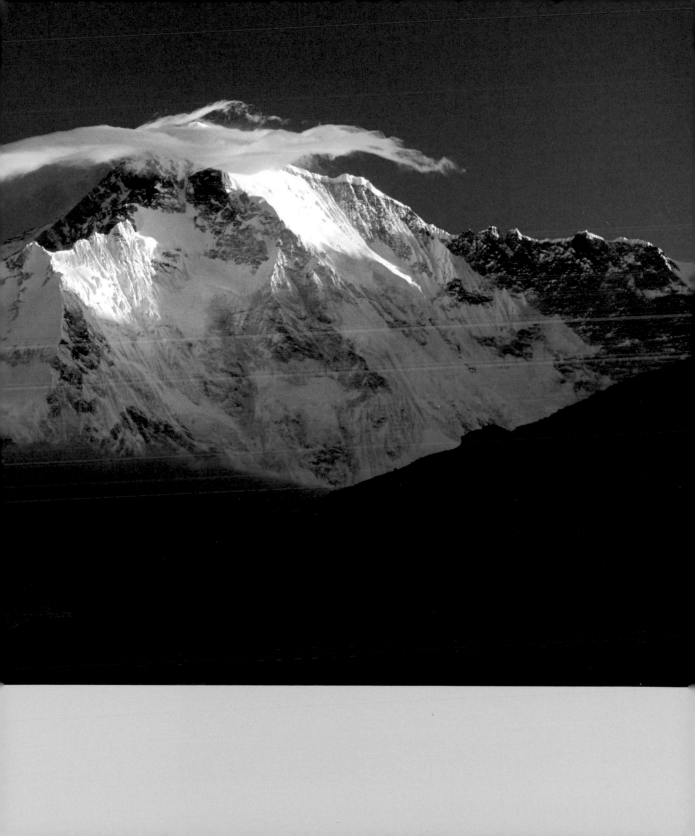

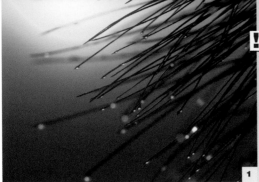

> ! If you shoot at the sun with the aperture wide open so that you get a shallow depth of field, you will need a very fast shutter speed. If your camera can't manage it, use a neutral density filter to reduce the light coming into the camera.

> ! If it's a cold night and the sun is giving off warm light, dew drops or condensation will form, as it often happens in spring and autumn.

# wide aperture shots

After a particularly cold night, the rising sun will warm the atmosphere and cause condensation to form. While not very attractive on your lounge window, outdoors is a different story. Step outside into the garden or further afield and you'll find plants and flowers sprinkled with water droplets. Include the rising sun in that shot and you have the perfect record of a sharp, cold morning.

## shoot

Dirck DuFlon of Clermont, Florida, USA, shot this image with a Minolta prosumer digital compact with a built-in 27–200mm zoom lens. Dirck was walking with his dog early one morning when he took this photo. The sun had just risen and was filtering through the low-lying fog, when sparkles of light coming through the dew drops on the needles of a small pine tree caught his eye. He selected a wide aperture to soften and blur the background and some of the droplets. Then he zoomed in to isolate the tips of the needles, deliberately overexposing the sun so that the rich colours in the rest of the image were retained.

**2 levels**

## enhance

The Levels command was used to add more contrast to the image. The input slider on the left was moved inwards to use more tones in the range and the mid-point slide was moved to the right to darken the image slightly (2).

> ! When shooting scenes like this where there is a very bright background, it is worth taking two shots – one for the highlights and one for the shadows – to combine them later.

**3 hue/saturation**

The saturation was increased by 20% using the Hue/Saturation control. The original image was flat and the colours muted (3).

The Dodge and Burn tools were used to selectively lighten and darken areas of the picture (4).

**4 dodge and burn**

> digital capture
> levels
> hue/saturation
> dodge
> burn

**1/** While walking with his dog one morning, Dirck DuFlon spotted these droplets sparkling in the sun.

**2/** Levels was used to add contrast to the image.

**3/** Saturation was increased by 20%.

**4/** The image was selectively lightened and darkened in areas.

**5/** With enhanced contrast and colour, the early morning condensation really stands out on the leaves of this plant, with the halo of the sun in the background.

## enjoy

Dirck generally makes prints for his own enjoyment and has exhibited some of them on occasion. There were some problems converting this image to CMYK for reproduction in this book as the bright colours around the sun were out of the CMYK gamut. The contrast had to be increased to compensate.

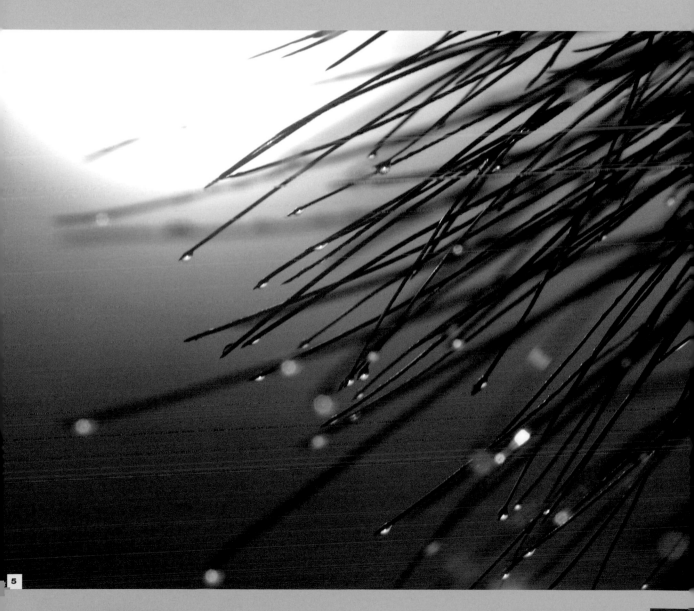

5

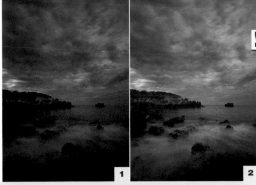

! The sky is likely to be a good deal lighter than the sea, even given its reflective capabilities. It may be worth using a graduated neutral density filter to cover the sky and balance the exposure out.

! Colour filters can increase the sense of drama in the sky, but remember to also use a manual white balance setting as the camera will react to the colour otherwise.

# capturing changing light

Red sky at night, shepherds' delight, red sky in the morning, shepherds' warning – so the old saying goes. A stormy morning is worth getting out of bed for because not only does the low light level allow you to shoot a long exposure, the sky will also be red and angry, with the light burning on the heavy rain clouds. Bring your waterproofs and get set up to catch the light as it changes rapidly with the coming of the sun.

> digital capture
> RAW conversion
> layer mask
> copy and paste
> gaussian blur
> levels
> curves adjustment layer
> levels adjustment layer
> selection
> colour balance
> plug-in action

## shoot

Armed with a Fuji digital SLR and a Sigma 12–24mm EX wide-angle lens, Wayne Willis of Mount Gambier, Australia, was ready and in position as a storm rolled in. It was 20 minutes before sunrise at Southend in South Australia and the sky was putting on a pyrotechnic show.

Wayne shot the image in RAW format, then produced a lighter and a darker version in the RAW conversion software (1/2).

**3 layer mask**

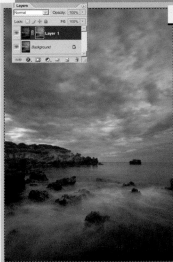

## enhance

Both images were loaded into Photoshop and the darker image was copied on to the lighter one.

A layer mask was created on the darker image and then the lighter image was copied and pasted on to the layer mask on the dark image (3).

The Gaussian Blur filter was run on the layer mask to make it smoother and then the contrast on the layer mask was reduced by using Levels (4). The Output Level was moved to 58 and 193, which cut the tonal range down and lowered the mid-point. The layers were then merged.

Adjustment layers for Levels and Curves were applied to the image to tweak the brightness and contrast (5).

The sky and sea were selected and the Colour Balance function used to increase the cyan and blue components, giving the clouds the

**5 curves**

**4 levels**

feeling of an impending downpour, which was actually the case at the time (6). A Fred Miranda Velvia action was run before the layers were merged.

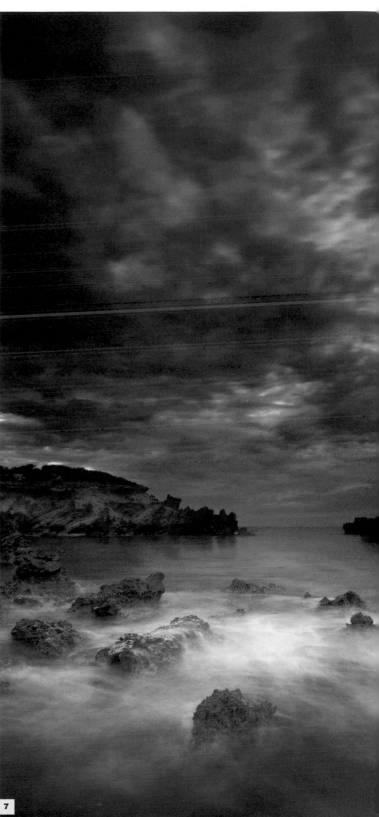

! Your exposure time needs to be between 8 to16 seconds to successfully blur the water. If you can't get this, even while using the narrowest aperture on the lens, then use a strong neutral density filter to block out more light. They come rated according to how many stops of light they cut out.

## 6 colour balance

Color Balance
Color Levels: -22  -15  +14

Cyan ——————— Red
Magenta ——————— Green
Yellow ——————— Blue

Tone Balance
○ Shadows  ◉ Midtones  ○ Highlights
☑ Preserve Luminosity

OK
Cancel
☑ Preview

Layers
Normal  Opacity: 100%
Lock:  Fill: 100%

Curves 1
Levels 1
Background copy
Background copy 2
Background

## enjoy

**1 2/** Both of these originals are from the same RAW exposure. They were created two exposure stops apart in the RAW processing software.

**3/** A layer mask was created on the darker image.

**4/** Contrast was reduced using Levels.

**5/** Curves was applied to adjust brightness and contrast.

**6/** Cyan and blue components were increased.

**7/** The final image captures and displays the stormy morning conditions.

Wayne takes and prints photos for his own enjoyment. He has sold one copy of this image to a friend. For web use he resizes his images to make them smaller and uses the Save for Web option to optimise. Wayne prefers to concentrate on seascapes and macros as he really likes the sense of moving water and the dynamic nature of the sea.

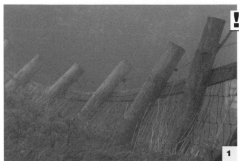

**1**

!| Mist is reflective, being water particles in the air. That means it has the potential to fool metering systems. Try exposure compensation with +1/3 EV when shooting misty scenes.

!| The automatic white balance can make anything of the colour of light once it has been filtered by the mist. You are advised to try a few shots with a manual white balance setting just in case.

# diffuse lighting

One of the signature effects of early morning is that if the temperature rises after a cold and wet night, then condensation and mist duly form. The sun may not be visible when it rises, but it will make itself known by the diffuse spread of light shining through the mist. It's like having the world's biggest softbox and simply adds to the atmosphere of the shot.

## shoot

One spring morning, Chris Spracklen and a friend were on Eggardon Hill near Powerstock in southwest Dorset, UK, waiting for a spectacular sunrise and arresting vista. Unfortunately, the whole area was blanketed in heavy mist so, instead, they stumbled around looking for anything photogenic on a smaller scale. Chris shot this image with a Nikon digital SLR and an 18–70mm DX Nikkor lens. He particularly liked the way the fence leaned and lead into the mist.

**2 auto levels**

**3 hue/saturation**

## enhance

The image was opened in Photoshop CS and the Levels adjusted using the Auto option, together with some further darkening of the middle greys (2).

The original layer was then duplicated and colourised using the Hue/Saturation control (3).

Next, the blending mode on the duplicate layer was set to Hard Light, allowing much of the original colour to show through (4).

The duplicate layer was then darkened using the Levels function, dropping the middle greys to a value of 75 (5).

**4 layer blend**

!| Focusing can be problematic in misty conditions. Either select something that contrasts with the rest of the scene or use manual focusing.

**6 selection**

> levels
> duplicate layer
> hue/saturation
> hard light blend mode
> levels
> selection
> levels
> layers flatten
> frame

**5 levels**

**1/** It takes a keen photographic eye to see the potential in this dull and dreary shot. Happily for this book, Chris Spracklen has just such an eye.

**2/** Auto Levels was applied to the image.

**3/** The original layer was duplicated and colourised.

**4/** Blending mode was then adjusted.

**5/** Levels was used to drop the middle grey value.

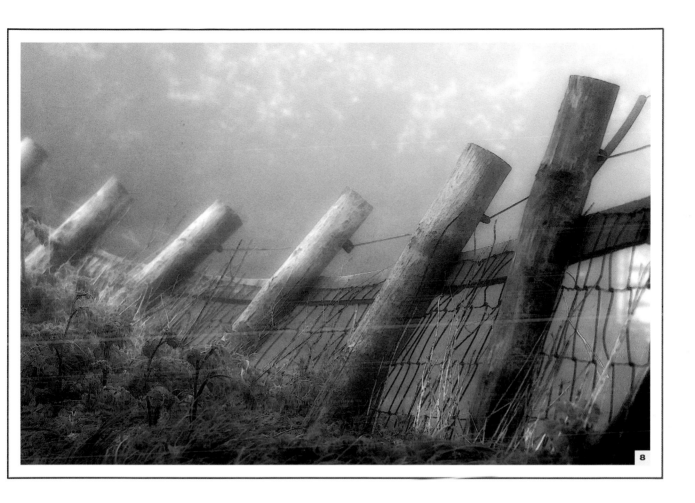

8

A rough selection of the misty background was then made. The selection was feathered by 150 pixels to give a very soft edge, and the Levels for that selection were adjusted again (6).

The layers were then flattened and the Image dropped on to one of Chris's ready-made frame templates. This is the finished image prior to the frame being added (7).

**7 | flattened**

6/ A selection was made and feathered.

7/ Layers were flattened and framed.

8/ Through the miracle of Photoshop, the image is now mysterious and intriguing, and framed.

## enjoy

While the image hasn't been printed as yet, it has been resized and uploaded to the two websites where Chris stores and exhibits photos. It was also converted to CMYK and the contrast adjusted for use in this book.

1

! When shooting in the golden hour of sunrise, do not use automatic white balance as it will negate the colour effects. Set the white balance manually to a high setting.

# capturing early morning light

The attraction of being in a big city when the sun comes up is that firstly, the light is a marvellous golden colour. Secondly, the architecture of the city itself produces shapes, forms, shadows and reflections. Everyday street elements that would not be worth capturing during the regular daylight hours are transformed with the sunrise.

## shoot

While on a trip to San Francisco, Jon Bower of the UK got up early while jetlagged and wandered around the city with his camera. As the sun came up, golden light was cast across the city, making this scene an obvious photographic opportunity.

## enhance

The first step was to tweak the Levels and the Curves to introduce more contrast into the scene, without sacrificing the highlights (2).

The saturation was then increased with the Hue/Saturation control, particularly in the yellow spectrum to replicate the golden colour seen on the day (3).

Finally, there was some chromatic aberration, or colour fringing around the vertical structures. The Clone Stamp tool was used in colour mode to nibble these away (4).

2 **curves**

Channel: RGB

OK
Cancel
Load...
Save...
Smooth
Auto
Options...

Input: 70
Output: 59

☑ Preview

! Look around before the sunlight appears and get into position so that you can capture the location and then move on to the next. You only have a limited time before the light changes colour.

3 **hue/saturation**

Edit: Yellows

OK
Reset
Load...
Save...

Hue: 0
Saturation: +15
Lightness: 0

15°/45°     75°\105°

☐ Colorize
☑ Preview

**1/** The original image is flat and lacks the colour and contrast seen on the actual day.

**2/** Curves was used to add more contrast.

**3/** Saturation was increased.

**4/** The Clone Stamp tool was used to eliminate colour fringing.

**5/** After contrast and saturation adjustments, the original capture now resembles the conditions found on the morning the picture was taken.

> file capture
> hi-res scan
> levels
> curves
> hue/saturation
> clone stamp

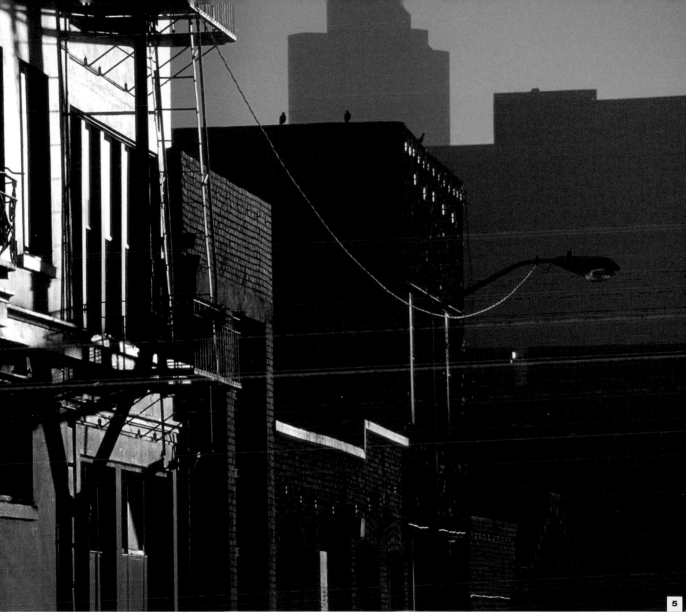

## 4 clone stamp

**!** Note where the sun is going to rise and examine the buildings facing it – this is where you will be shooting.

## enjoy

While shot on film, this image required digital editing to bring it up to scratch. The slide was scanned at a very high resolution and worked on in Photoshop. Jon uses the Adobe RGB colour profile as it offers a wide range, which is important when scanning work. Jon generally makes prints for his own use or for exhibition. His commercial work is almost entirely web-based.

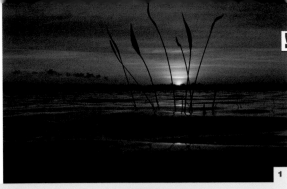

! Make sure your tripod isn't prone to rust if you are going to be standing in water.

! An ultraviolet or UV filter screwed over the end of the lens will protect it from splashes of water.

! Alternatively, use a longer lens and zoom in so that you appear to be right over the water.

1

# reflected sunlight

As the sun comes up and squeezes over the horizon it will cast its light into the sky and show reflections across the waves. If you catch the sun right as it comes over the horizon and get the camera down to water level, you can capture splashes of light and reflections in the waves as they roll in.

> digital capture

> polygonal lasso

> colour balance

> invert

> colour balance

> duplicate layer

> blending change

> duplicate layer

> layer mask

> hue/saturation

> curves

## shoot

Peter Anderson lives on a lake just south of Orlando, USA. Often he wakes up to a wonderful sunrise. On this particular November morning, the clouds were quite low and dark, but the sun managed to make an appearance. The plant pictured is commonly called Duck Potato – it has a broad green leaf and long curving stem. In the mornings, the lake is usually quite calm. However, the stormy weather during the shooting of this photograph meant windy conditions, allowing for reflections of the sunrise on the waves, which contrasted with the silhouette of the plant. Peter shot it with a Canon digital SLR. He used spot metering from the weak sunrise, which turned the plant into a silhouette, but was bright enough to catch the highlights on the waves.

1/ The original image has a good exposure and great composition, but lacks colour.

2/ The image was selected using the Polygonal Lasso tool.

3/ Colour Balance was used to increase the red component and add warmth.

## 2 polygonal lasso

## 3 colour balance

4/5 Duplicate layers were created and worked on.

6/ The saturation was increased.

7/ With completely reworked colour and a brighter image, Peter Anderson has captured sunrise over the lake perfectly.

## enhance

The centre of the image around the sun and the surrounding clouds was selected with the Polygonal Lasso tool. It was then feathered by 100 pixels (2).

Colour Balance was used to increase the red component so that a warmer sunrise could result. The selection was then inverted (3).

The Colour Balance control was used again, this time to make the clouds and water have a blue-purple cast to them.

A duplicate layer was created and renamed Layer 2. The blend mode was set to Soft Light and the Opacity set to 35%. This increased the contrast in the image (4/5).

Another duplicate layer was added, this time with the blend mode set to Colour Dodge. The Opacity was reduced to 35% and a layer mask added. This was filled so that all the effect was blocked except along the horizon where it boosted the colour.

Hue/Saturation was used to increase the saturation and Curves used to add a final amount of contrast (6).

## 4 duplicate layer

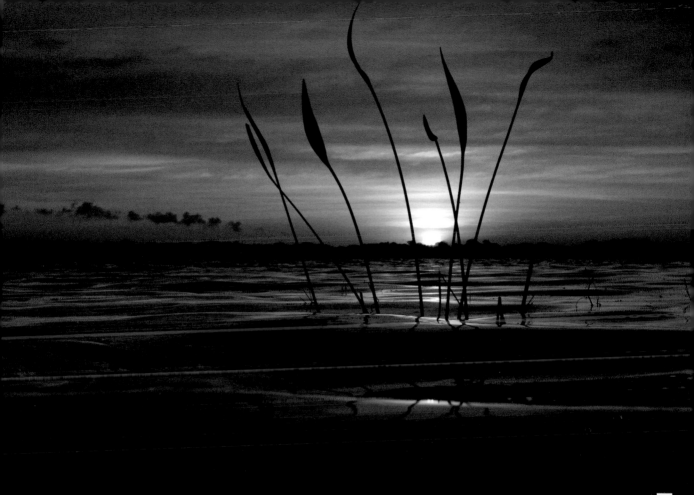

## 6 hue/saturation

Edit: Master

Hue: 0

Saturation: 20

Lightness: 0

OK
Reset
Load...
Save...

☐ Colorize
☑ Preview

## enjoy

Although Peter shoots primarily for his own enjoyment, a low-resolution version of this image was placed on the digitalphotocontest.com website where it won photo of the day. He prefers the Adobe RGB colour profile for providing the best balance of colour when editing in Photoshop.

## 5 duplicate layer

Layers  Channels  Paths

Color Dodge    Opacity: 36%

Lock: ☐ ☑ ☒ ☐    Fill: 100%

Laye...

Layer 2

Background

**8/ ALTERNATIVE IMAGE:** The photo below was taken by Marcio Cabral at Fernando de Noronha, one of the most beautiful islands in Brazil. He used a Singh-Ray Gold-N-Blue polariser filter to improve the golden reflection on the sea and a Hi-Tec

tobacco graduating filter to enhance the colours of the sky. He also used a Singh-Ray Reverse Grad 2 stops filter to balance the light contrast.

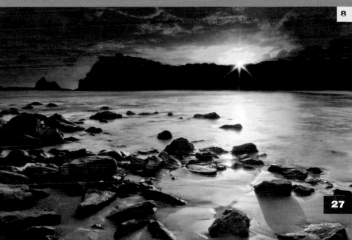

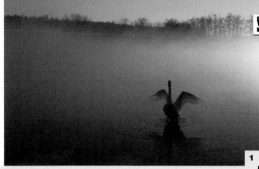

# touching-up

Water always makes for an interesting element in a photograph, never more so than when it features on a warm morning, following a cold night. Mist is the inevitable result. Watch for the sunrise, which turns the vapour into a sheet of golden light. If you're very lucky, you might just catch wildlife, particularly birds, in the scene.

## shoot

Roger Tan of Guangzhou, China, witnessed just these conditions at Unterdiessen in Bavaria, Germany. This is a natural lake where different types of bird flock all year round. The previous night was cold and frosty,

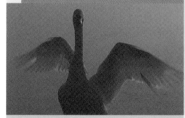

**2** cut and paste

but the next morning, bright sunshine turned the winter scene into a thick layer of golden coloured fog. After a while, Roger spotted a couple of white swans moving through the fog towards him – one swan in particular swam right to him. Roger returned the sounds the swan was making and as a result, it flapped its wings breaking the thin sheet of ice on the surface. At that point Roger snapped away with his Sony digital camera.

**4** erase

**5** burn tool

## enhance

The bird was missing a feather on its right wing so a feather was selected on the left wing, copied and pasted as a new layer (2).

The feather was flipped horizontally and rotated to fit the damaged area. The Layer Opacity was temporarily reduced to 60% so that Roger could see through and judge the positioning accurately (3).

A soft edged Eraser was selected and used to erase the unwanted portion of the new feather (4).

The new feather was brighter than the rest of the wing so the Burn tool was used with 8% exposure on the midtones to darken it (5).

**3** rotate

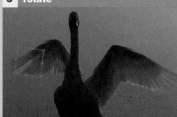

The Clone Stamp tool was then used to remove a tiny condensation cloud from an aeroplane, as well as a small patch of grass in the bottom right corner (6).

**6** clone stamp

> digital capture
> copy and paste
> flip and rotate
> eraser
> burn
> clone stamp

## enjoy

Roger makes prints for his own enjoyment and also for exhibition use. This picture was chosen by one of his clients for some of their portraiture instruction sessions as a background to superimpose figures on to.
For resizing for use on web pages, Roger uses the Photoshop Save for Web feature.

1/ Roger Tan was up at daybreak on a freezing winter's morning, and was rewarded by this display.

2/ A feather was copied and pasted as a new layer.

3/ The copied feather was rotated to fit the area.

4/ Unwanted sections were erased.

5/ Midtones were darkened.

6/ The Clone Stamp tool was used for tidying up.

7/ The swan's missing feather was replaced to restore the bird to its full glory.

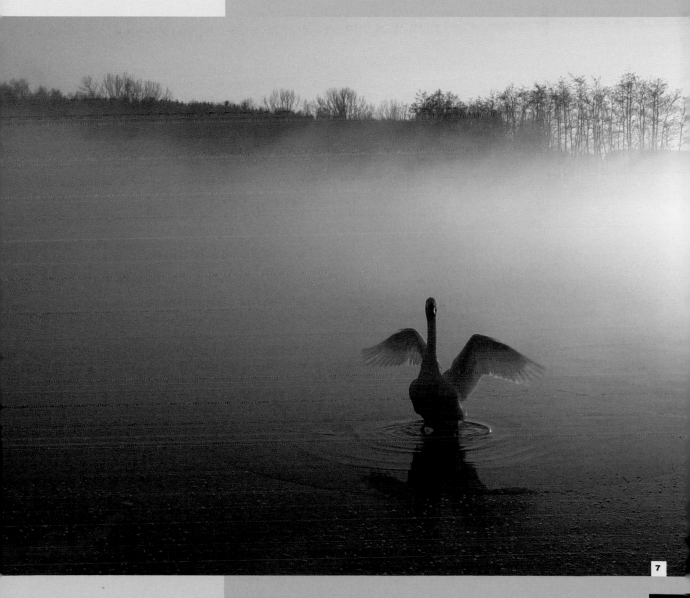

7

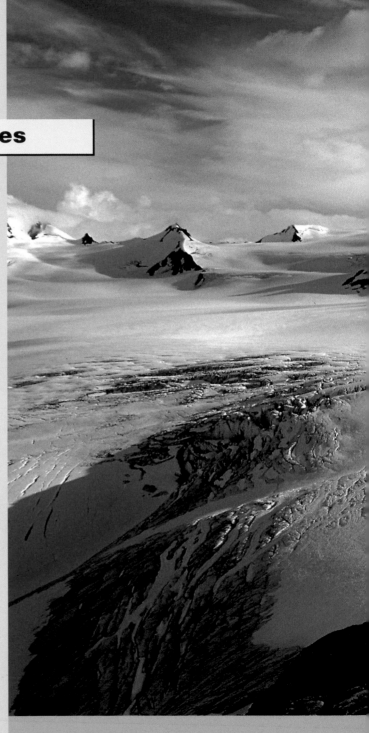

# 3 shimmering landscapes

When the full glare of the midday or afternoon sun is beating down, most photographers head indoors or put their feet up. However, you can pick up the gauntlet and challenge these conditions to produce pictures that exploit the very harshness of the light. From baking deserts to shining seas and sparkling snow, if you know how to beat the conditions, then great photographs against the odds can be yours.

Martin Wierzbicki shot this awesome vista of the Harding Icefield in Alaska with a Canon 28–125mm f3.5 telephoto lens.

Martin says, 'It took an hour and a half to climb to the viewpoint, with the last half hour hiking through ankle-deep snow. The view was well worth the climb. Far below, the Harding Icefield stretched out as far as the horizon, an enormous sheet of snow and ice the size of Rhode Island.'

**photographers**

Martin Wierzbicki
Jeff Alu
Patricia Marroquin
Dirck DuFlon
Ilona Wellmann
Duncan Evans

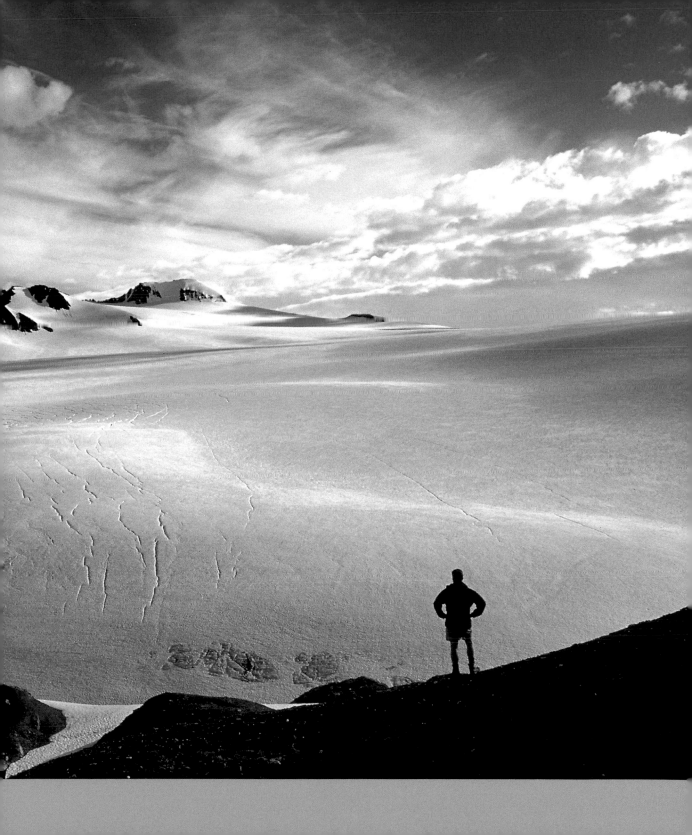

! It's worth using a graduated ND filter on the sky because while the ground will probably be reflective, at this time of day the sunlight will be intense. The filter will balance the exposure so that the foreground isn't dark.

**2 channel mixer**

! Look for tracks, cracks and features in the ground and compose the image accordingly. Trails that run from the foreground to the mid-ground will lead the eye into the photo.

# balancing exposure

The scorched, baked plains of a desert show the power of the sun to a frightening degree. There isn't even the desolate beauty and sweeping curves of sandy dunes – just hard, flat mud along with baked and cracked rock. To shoot something like this in the midday sun, when the heat and glare are at their worst, simply amplifies the sense of extreme light and hostile conditions.

## shoot

This shot was taken by Jeff Alu at Galway Dry Lake in the Mojave desert. The temperature was above 100 degrees Fahrenheit that day so Jeff had to shoot quickly with his Kodak digital camera. He was all alone and it lent a strange, forgotten yet deadly atmosphere to the scene. Jeff very rarely puts the sun right in the field of view, but he had a feeling this should be one of those times. This was a gamble because the shot was unfiltered and glare could have ruined it – but this time he was lucky.

## enhance

The first stage was to convert the image to black and white using the Channel Mixer with the monochrome box checked. The RGB sliders were adjusted to get as close to the desired look as possible (2).

After that, the Dodge and Burn brush was used to bring out the motorcycle tracks, and also to burn the hills in the background so that they were completely black (3).

The Dodge tool was then used to lighten the surface of the lake bed slightly, bringing out the highlights. It was also used to highlight the edges of the small clouds (4).

Afterwards, the Unsharp Mask filter was applied with a large radius and a small amount. This brought out

**3 dodge and burn**

**4 dodge and burn**

certain details in the image. It was used again, this time with a small radius and a larger amount, to sharpen the image on a smaller scale (5/6).

**5 unsharp mask**

OK
Reset
☑ Preview

100%

Amount: 25 %

Radius: 50 pixels

Threshold: 3 levels

**6 unsharp mask**

> digital capture
> channel mixer
> dodge
> burn
> unsharp mask

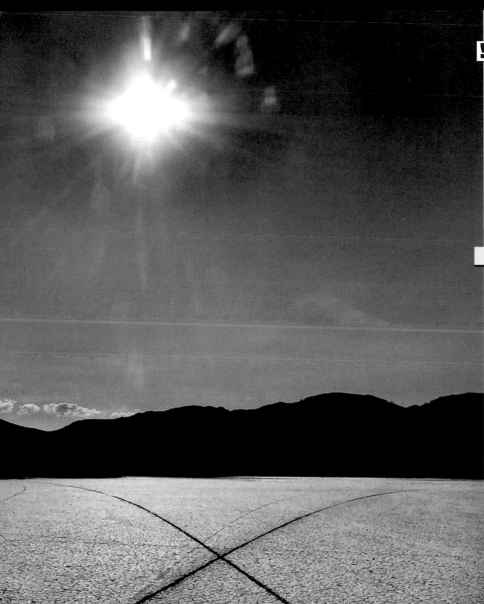

## enjoy

Jeff gets prints made and has some
hanging on his walls. He also does a lot
of gallery exhibits and has mounted
and framed prints for that purpose.
He has sold a few prints at these
exhibitions, but has sold more to
private individuals via his website.
For printing, he uses an online resource
called ezprints.com.

1/ Out in the lonely desert, under a baking hot
sun, the landscape is bleak and barren.

2/ The image was converted to monochrome.

3/ Selected details were enhanced or burned.

4/ The surface of the lake bed was lightened.

5/6 The Unsharp Mask filter was applied to
sharpen and enhance aspects of the image.

7/ With the detail brought out, the full
intensity of the scorched desert plain
is revealed.

7

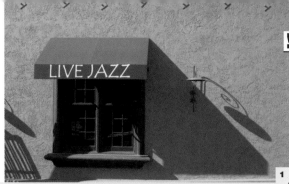

# patterns and shadows

As the sun beats down at midday or early afternoon, it can make landscape photography exceedingly difficult. However, if you are in a town, why not turn your camera away from the sky and search out the shadows on buildings? If you can find attractively coloured walls, the sun will make them vivid as digital tends to prosper in strong light, where it isn't aimed directly at the camera. Look for shapes, patterns and interesting shops and buildings.

## shoot

The coastal southern California city of Ventura, USA, has a charming downtown with shops and restaurants. When Patricia Marroquin of Oxnard, California, visits, she parks next to Café Fiore, an Italian restaurant. The side of the building has several windows with overhangs bearing various signs: Live Jazz, Cocktails and Pizzeria. Patricia was passing one afternoon and noticed the interesting shadows in the harsh afternoon light. She captured the image with a Canon digital SLR using a Sigma 28–300mm superzoom lens.

**!** You should look for shapes that shadows form on the buildings. The best ones to capture are either very ornate ones or those that don't resemble the structure from which they are cast because of the angle of the sun.

> digital capture
> straighten image
> warmth/brilliance plug-in filter
> skylight plug-in filter
> brightness/contrast
> unsharp mask

## enhance

The original image was slightly askew so the first task was to straighten it using the semi-automatic Straighten Image option in Photoshop Elements (2).

The contrast and warmth of the image was increased through the use of a plug-in filter called Color Efex Pro (3).

Another filter in the same plug-in package (Skylight) was then used to reduce the haze effect caused by the ultraviolet light in the scene (4).

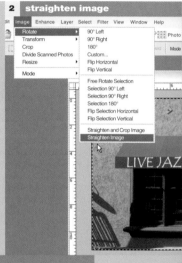

**2** straighten image

**3** brilliance/warmth

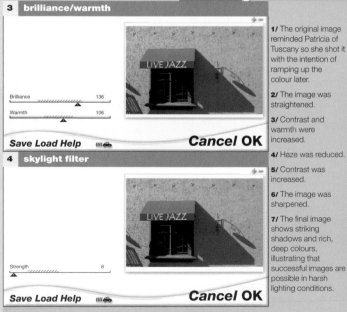

Brilliance    136
Warmth    106

Save Load Help    Cancel OK

**4** skylight filter

Strength    8

Save Load Help    Cancel OK

**1/** The original image reminded Patricia of Tuscany so she shot it with the intention of ramping up the colour later.

**2/** The image was straightened.

**3/** Contrast and warmth were increased.

**4/** Haze was reduced.

**5/** Contrast was increased.

**6/** The image was sharpened.

**7/** The final image shows striking shadows and rich, deep colours, illustrating that successful images are possible in harsh lighting conditions.

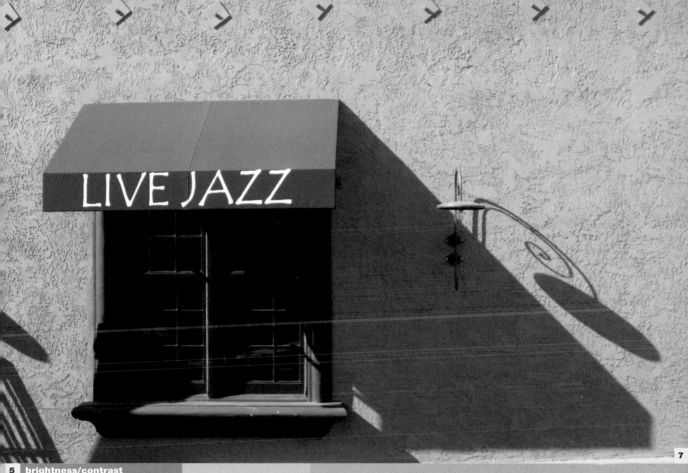

## 5 brightness/contrast

Drightness: 0

Contrast: +10

OK
Cancel
Help

☑ Preview

The simple Brightness/Contrast slide was then used to increase the contrast by 10% (5).

Finally, as pictures from the Canon are usually quite soft due to a CMOS chip rather than CCD, Patricia used the Unsharp Mask filter to make the image much sharper (6).

## 6 unsharp mask

OK
Reset
☑ Preview

Amount: 100 %

Radius: 3.5 pixels

Threshold: 42 levels

## enjoy

Patricia makes prints for both personal and commercial use. She likes to give framed prints to family and friends as gifts. Some of her images have appeared in the Ventura County Star where she works. She has made a few sales via her online gallery: www.BetterPhoto.com. A purchaser has used one of her prints to serve as an inspiration while working on a mural to evoke themes of relaxation and serenity. Another customer bought a print to turn into a quilt for her daughter-in-law. Patricia's images have won awards at her local county fair (Ventura County Fair) and the State Fair of Texas in Dallas. She has also sold some images on micropayment stock photo sites.

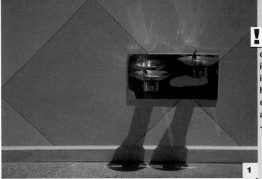

! In very bright, reflective areas such as this, the camera's zone metering will invariably underexpose the image. While this will ensure highlights are not lost, you can get a better tonal range and still be safe by dialling in +1/3 or up to +2/3 EV.

**1**

# bright reflections

Harsh midday sun will cast deep shadows, but also reflect vividly from anything made of glass, steel or reflective metal. Look around you in the typical big city, where plazas tend to have chrome fittings or metallic sculptures. Search out subjects that would not normally make a very interesting photograph, and see what it looks like under the bright glare of the sun. The combination of reflections and shadows will lift it out of the ordinary.

## shoot

This photo was taken at Downtown Disney Westside in Lake Buena Vista, Florida, USA by Dirck DuFlon of Clermont, Florida. He shot it with a Minolta prosumer digital compact using a Hoya R72 infrared filter. The sun was high in the sky and it was being reflected by the highly polished bowls of a drinking fountain. This made some interesting, bright patterns against the cement wall, and left strong shadows underneath. Dirck had been shooting with his infrared filter and liked the way it lightened the colours of the wall, but retained a nice range of tones in the fountain itself. He shot this using the camera's black-and-white mode.

**2  levels**

**3  dodge tool**

## enhance

First, a duplicate layer was created. As it was underexposed and the whole point of the image was the reflections and shadows, the Levels control was used to really brighten the white tones and darken the shadows, while lightening the picture overall (2).

The Dodge tool was then used on the highlights and reflections to make them stand out. The Burn tool was used on the shadow areas to bring out the textures, lines and edges (3).

In places where this work had resulted in blown-out highlights, the

**4  eraser**

**5  burn tool**

Eraser was used to knock the effect back by revealing some of the original layer underneath (4).

Finally, the Burn tool was used with a very large brush to make the corners of the picture darker, adding a vignette effect that concentrated the viewer's attention on the objects in the centre (5).

> digital capture
> duplicate layer
> levels
> dodge
> burn
> eraser
> burn

## enjoy

Dirck operates on the philosophy that image editing should be there to help the digital image reach what was observed on the day. He has reduced this image in size and saved it as a JPEG for display on his web space, but has not made any commercial sales with it as yet.

**1/** The original image of bright reflections from the polished water fountain was somewhat underexposed.

**2/** Levels was used to brighten the white tones.

**3/** The dodge tool was used to make the highlights stand out.

**4/** Some of the original layer underneath was exposed.

**5/** The Burn tool was used to create a vignette.

**6/** The real harshness of the light is fully utilised here, with deep, dark shadows and sparkling reflections on the wall.

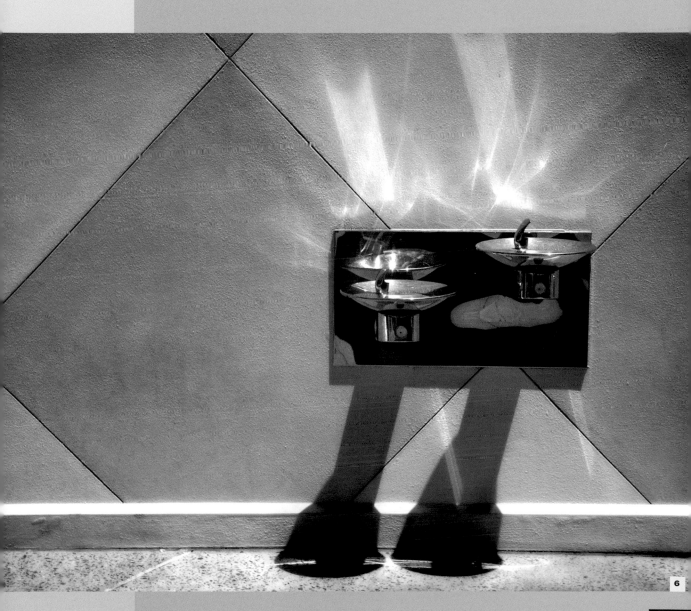

6

! If you attempt to use exposure compensation to make the landscape brighter, the sun will simply flare out and turn that part of the image white. You are better underexposing the rest of the image and capturing a smaller sun shape.

**2  levels**

Channel: RGB

Input Levels: 04  0.83  196

OK
Reset
Load…
Save…
Auto
Options…

Output Levels: 0  255

☑ Preview

# shooting the sun

During most hours of the day the sun is extremely bright, so when using any metered exposure mode on your camera, it will affect the exposure, making it much faster. This results in the sun acting as a flashlight in the sky, complete with lens flare effects. The landscape will be darkened to the point of blackness, due to the exposure being so fast. One exception to this is bright sunshine over sea or snow, as the reflective properties of both will ensure that they are almost as bright as the sun, and so are recorded well.

## shoot

This was the kind of scene faced by Ilona Wellmann of Gummersbach, Germany. It was a winter afternoon in the Erzgebirge Bayern region of Germany and Ilona used a Sony digital camera fitted with a Hoya polarising filter. The filter can reduce reflections (i.e. from snow), so that it is rendered without undue glare. It also reduces the light for the exposure by one or two stops, which can be useful on extremely bright days.

## enhance

The Levels were first adjusted to spread the tonal range out as the body of the image was underexposed. As the midtone marker moves automatically with the adjustment, it was repositioned near to its original position (2).

The Curves function was then used to brighten the midtones of the image, and slightly darken the shadows without affecting the sun as the rays would be filled-in (3). A third party plug-in filter, Nik Color Efex Pro,

was then used to adjust the brilliance and warmth of the image, giving it a cooler and bluer colour cast.

**3  curves**

Channel: RGB

OK
Reset
Load…
Save…
Smooth
Auto
Options…

Input : 38
Output : 34

☑ Preview

! When shooting right at the sun with snow in the scene, the very brightness of the sun will work for you. The snow will not be rendered as a dark shadow like everything else in the scene because it is very reflective, but as it is less bright than the sun, it will be darker and all the tone will be retained.

> digital capture
> levels
> curves
> plug-in filter
> alternative image

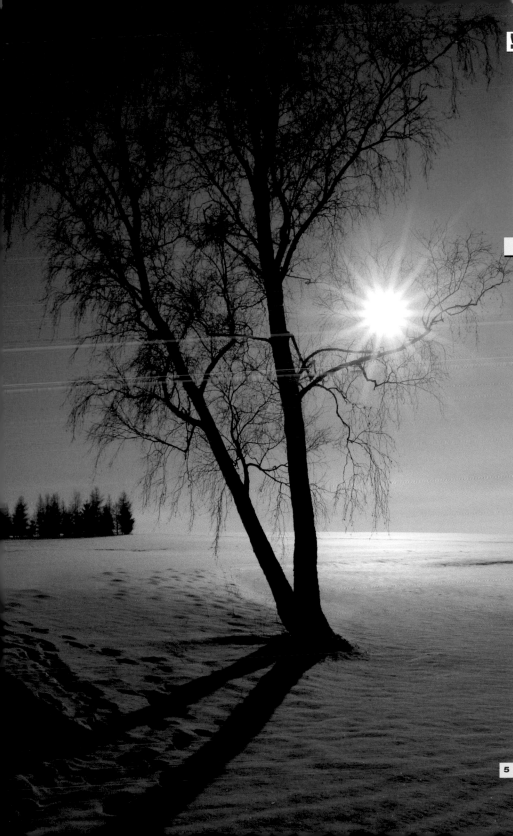

If the sun is near the top of the scene, a graduated neutral density filter can even the exposure up a little, ensuring that non-snow or water scenes retain some detail under the blazing sun.

## enjoy

Ilona has been a semi-professional photographer for four years and is still working hard to teach herself the technicalities of photography, while developing a distinctive style based on her own concept of creativity. She has made prints of this image for exhibitions and contests.

**1/** The original image that Ilona shot is muted, with the general landscape underexposed.

**2/** The tonal range was spread out using Levels.

**3/** Midtones were brightened and shadows slightly darkened.

**4/** This alternative image was shot closer to the tree and slightly later so that it is more direct, and cuts out most of the footprints in the snow.

**5/** The final image has more punch and greater tonal range than the raw capture, but all the detail in the snow has been retained and enhanced.

5

# snow and ice

Whether shooting under sunny conditions or the cloudiest of days, snow and ice have enormous reflective characteristics that are guaranteed to fool all metering systems. Camera metering is designed to read the light reflected back from scenes with typical or average reflectivity, whereas snow and ice are much more reflective. This results in the camera thinking the scene is brighter than it actually is. It sets the exposure accordingly, and consequently underexposes the scene.

> digital capture
> levels
> curves
> colour balance
> clone stamp

## shoot

This photo came from the same session by Ilona Wellmann (see previous spread). She was in the Erzgebirge Bayern region in Germany with her Sony prosumer digital compact, shooting in sunny conditions on a snowy winter's afternoon. She was attracted to the unusual shapes produced by the snow-covered signs, lit by the bright sun. The image was shot with a Hoya polariser filter fitted to the camera. This can block reflections, reducing glare from reflective surfaces down to pinpoints of light.

**2  levels**

Channel: RGB
Input Levels: 0    0.00    208

OK
Cancel
Load...
Save...
Auto
Options...

Output Levels: 0    255

☑ Preview

**3  curves**

Channel: RGB

OK
Reset
Load...
Save...
Smooth
Auto
Options...

Input : 187
Output : 196

☑ Preview

**4  colour balance**

Color Balance
Color Levels: 5    0    0

Cyan ———△——— Red
Magenta ——△—— Green
Yellow ——△—— Blue

OK
Cancel
☑ Preview

Tone Balance
○ Shadows  ⦿ Midtones  ○ Highlights
☑ Preserve Luminosity

**!** When shooting in snowy conditions you might want to dial in +1/3 or +2/3 EV to compensate for the camera underexposure.

## enhance

The scene was underexposed, but more importantly, the full tonal range available wasn't used. The tones were all compressed, so the first thing to do was use Levels and drag the right carat on the input slider from the right until it met the data. This stretches out the tonal range, and as the midtone point marker moves as well, the image is also brightened (2).

The Curves function was then used to increase the contrast in the image. An S-shaped curve was

**5  clone tool**

used, but with only very small adjustments being required (3).

The image was slightly warm with a faint brown colour to the snow.

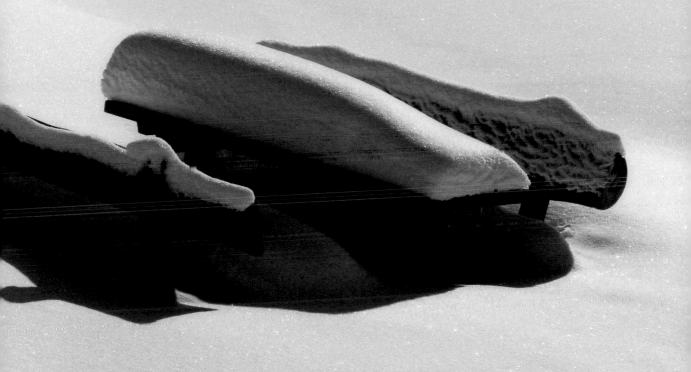

6

Colour Balance was used to shift from red to cyan to counteract this and make it look cooler (4).

Finally, the Clone Stamp tool was used with the mode set to Lighten, to remove the shadows and dirt on the bottom left of the image (5).

## enjoy

Ilona likes to make at least three captures of the same scene using different white balance settings, which she can later use for artistic purposes or pick from for the most accurate rendering. She makes prints for exhibitions and contests, aiming to produce work that has a creative element.

**! Watch out for lost highlights with a digital camera. If the sun is shining, either bracket from the exposures or let the camera underexpose and correct it later. Blown-out highlights are considerably harder to repair.**

1/ Due to the reflectiveness of snow and ice, the camera metering system has underexposed this original image.

2/ The tonal range was stretched.

3/ Curves was used to increase contrast.

4/ Colour Balance was adjusted to give the image a cooler look.

5/ The Clone Stamp tool was used to remove extraneous elements.

6/ The completed image has the tonal range stretched, contrast enhanced and distracting shadows removed.

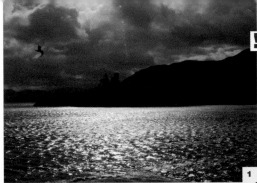

**!** The important factor in a shot like this is not to include the sun. A direct shot at the midday sun will turn the rest of the picture black, and also runs some risk of damaging the CCD in the camera.

**!** Use centre-weighted metering and meter off the shiny surface of the sea. This will guarantee that you get the proper exposure and not lose any highlights.

1

# metering

When the sun is overhead and beating down on an expanse of water, it tends to turn the colours silver and lead, producing a very shiny, reflective effect. Due to the extreme amount of light reflecting off the surface, the landscape elements of the photo will be rendered black in order to capture the light. You need to look for natural features that will still be visible and contribute to the picture, even if they are little more than silhouettes.

## shoot

This picture was shot at Kyleakin, the small village by the Isle of Skye road bridge in Scotland, UK. It was midday and normally this would preclude any photography, but the sea had turned silver and lead, so I shot across to the small ruined castle on the far bank, waiting until one of the circling seagulls cut across the picture. Although I kept the sun out of the shot due to the brightness, there is a trace of flare that runs through the picture. However, I feel this adds to the image. This was shot with a now discontinued Olympus fixed-lens SLR.

> digital capture
> channel mixer
> crop
> curves
> unsharp mask
> burn and dodge
> image size
> unsharp mask
> border

**2** channel mixer

Output Channel: Gray

Source Channels
Red: +40 %
Green: +20 %
Blue: +40 %

Constant: 0 %

☑ Monochrome

OK
Reset
Load...
Save...
☑ Preview

**3** curves

Channel: RGB

Input: 187
Output: 196

OK
Reset
Load...
Save...
Smooth
Auto
Options...

☑ Preview

## enhance

As there was very little colour in the image anyway, I decided to turn it into black and white. The Channel Mixer was used with settings of Red: 40%, Green: 20% and Blue: 40% to get a varied conversion that retained the highlights and shadows of the original image (2).

The image was then cropped into a vertical format to concentrate on all the important elements in the photograph which were on the left-hand side.

The Curves function was used to darken the land where the castle sits and slightly brighten the clouds behind it. Other control points were added to the curve to prevent different parts of the picture from being changed (3).

The Unsharp Mask filter was run at 100% strength to sharpen the picture and add definition (4).

The Burn and Dodge tools were used to darken and lighten parts of the clouds to make them more varied and stand out more (5).

**4** unsharp mask

100%

Amount: 100 %
Radius: 3.0 pixels
Threshold: 3 levels

OK
Reset
☑ Preview

Finally, the image size was increased to a more usable size and the Unsharp Mask filter run again at 25% strength to restore the sharpness lost through interpolation (6).

**1/** The original picture was taken In landscape format and included a circling seagull as well as the castle ruins.

**2/** The image was turned to black and white using Channel Mixer.

**3/** Select areas were brightened and darkened using Curves.

**4/** The Unsharp Mask filter was run to sharpen the image.

**5/** Detail and variety were added to the clouds.

**6/** The image was resized.

**7/** The main points of interest are all to the left side of the picture so I decided to crop it and turn the composition into a vertical one.

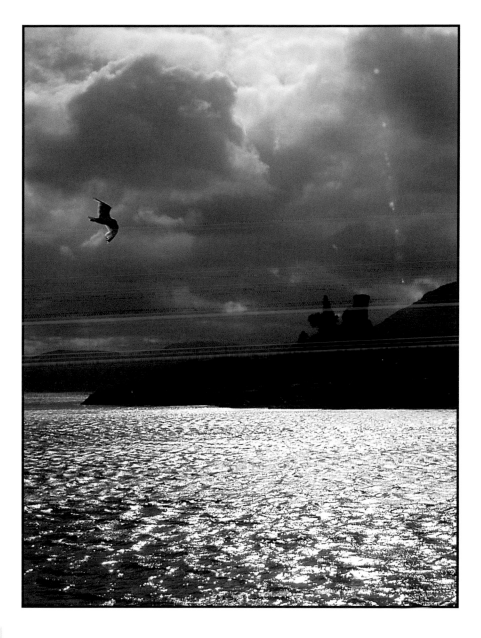

7

## 5 burn and dodge

## 6 resize

### enjoy

A version of this image was used in a magazine article about photographing landscapes. Also, a black-edged, white border was added to hold all the details in for printing. The image was printed out at A3 on a Canon six-ink printer.

**!** **Look for objects or birds that will add interest to the scene. Seagulls and boats are common and obvious props to use.**

# 4  sunset and night-time

One of the most popular times for photography is during sunset and later. All the colour and drama of sunrise are there, but you don't have to get out of bed as early. However, conditions at sunset and the potential for images change very rapidly – from soaking the scenery in golden light, looking away from the sun to a blaze of colour in the sky just after sunset, looking towards where it set. Later, the colours of the sky deepen and artificial lights come on - this is the perfect time to photograph man-made structures, combining artificial and natural lighting. Sunset and later offer the most varied and constant challenges to the digital photographer.

Fernando Pegueroles of Barcelona, Spain shot this image of Tossa de Mar with a Nikon consumer digital SLR, using a wide-angle lens and a Cokin graduated ND filter.

Fernando says, 'Tossa de Mar is a touristy place on the Costa Brava, Spain. During the winter, there is virtually no one there and I like to visit it to see the lonely beaches and the empty streets. At the end of the day, when the wall lights came on, I liked the contrast between the warm light and the cold, cloudy sky. I used a fisherman's boat beached on the sand to lead into the scene, then photographed the walls and the different lights."

**photographers**

Fernando Pegueroles
Duncan Evans
Jorge Coimbra
Marcio Cabral

Steven Rosen
Eskil Olsen
Kenny Goh
Mirko Sorak

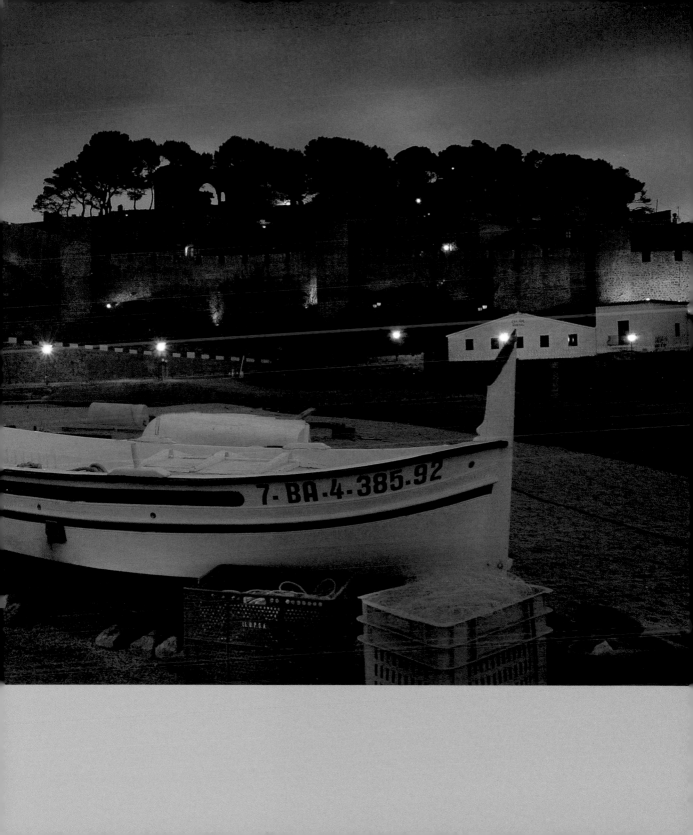

> When incorporating artificial lights into a darkening scene, keep taking shots as the relationship between the two will change constantly. The best shots are those where the artificial light adds to, instead of dominates, the scene.

> Bear in mind that when using wide-angle lenses, there will be greater distortion to anything very close to the lens. If possible, don't position a major vertical structure very close to the camera.

**1**

# sunset and clouds

While shooting directly at the sun is a difficult task, once it has set, the light still comes over the horizon and reflects off the clouds. These can then be set against a deepening blue sky for dramatic and colourful results. If you combine these conditions with the reflective possibilities of water, then you are well on your way to capturing a great sunset scene. All you need is a great location to set it all in.

## shoot

This sunset by Fernando Pegueroles of Barcelona was shot on a Nikon digital SLR using a Nikkor 17–80mm lens, Cokin graduated ND filter and tripod. The location is a village at the end of the Ebro river in Spain, where Fernando sometimes spends his weekends. One weekend he saw these typical winter clouds forming, so he waited next to the edge of the river until sunset. As well as shooting the usual pictures, he also waited until the wharf lights came on so he could capture the artificial element as well. A short time later, the wharf light was much too bright compared to the rest of the scene.

## enhance

The image was shot in RAW format then changed to JPEG for saving with the sRGB colour space.

Due to the wide angle used, the lamp was deformed. Fernando used the Transform> Perspective tool to straighten it (2). The image was then cropped. The contrast was adjusted using the Curves function (3). Finally, the Dodge tool was used on the mountains and trees to brighten them up a little (4).

**1/** The original image was shot in RAW mode on a Nikon camera so that a complementary colour space could be assigned later.

**2/** The image was initially straightened.

**3/** Contrast was adjusted using Curves.

**4/** The Dodge tool was used to add brightness.

**5/** The lamp post needed straightening and other elements brightening to arrive at this splendid final image.

**2  transform**

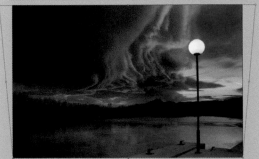

**3  curves**

Channel: RGB

OK
Reset
Load...
Save...
Smooth
Auto
Options...

Input: 64
Output: 59

☑ Preview

**6/ ALTERNATIVE IMAGE:** This image was shot outside East House on the Shetland Islands by Duncan Evans. As the sun set behind clouds on the horizon, it illuminated those overhead. A graduated neutral density filter was used to put some balance into the exposure.

> digital capture
> RAW conversion
> perspective
> crop
> curves
> dodge

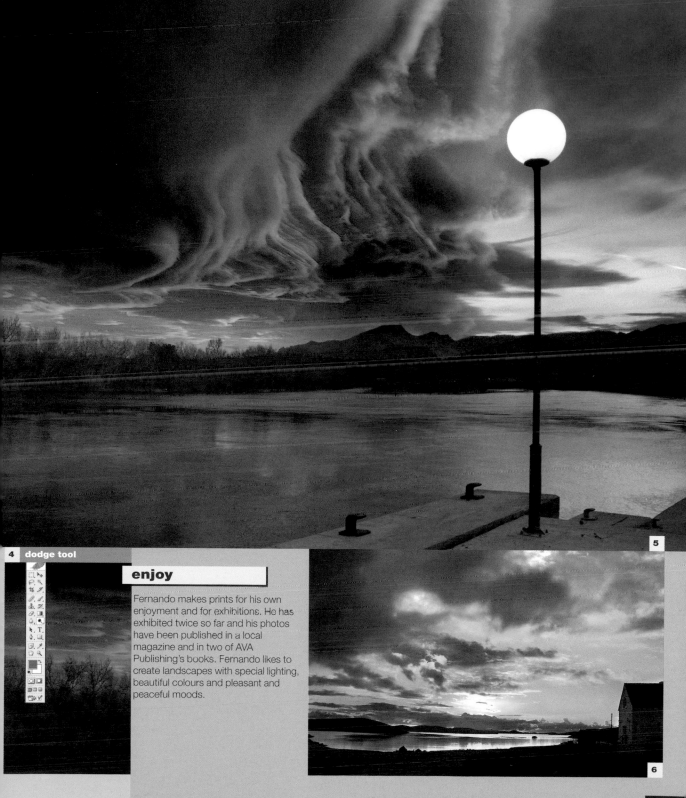

**4** dodge tool

**5**

## enjoy

Fernando makes prints for his own enjoyment and for exhibitions. He has exhibited twice so far and his photos have been published in a local magazine and in two of AVA Publishing's books. Fernando likes to create landscapes with special lighting, beautiful colours and pleasant and peaceful moods.

**6**

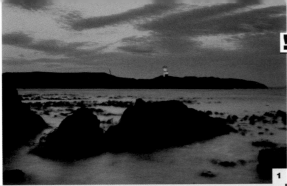

! After sunset, the landscape or seascape will be very dark, but the sky still light. Use a graduated neutral density filter to reduce the brightness of the sky and make the exposure within the range of the digital camera.

1

# lighthouses

The key factor when photographing a subject such as a lighthouse is to remember to place it within the context of its environment. That's usually treacherous rocks or perhaps a fast-flowing current. It should appear part of the environment as much as possible.

## shoot

This is the lighthouse just outside Elie Harbour, in Fife, Scotland. It isn't a particularly large or impressive lighthouse, but it is framed by jagged rocks and the current is strong and littered with seaweed. This was taken after sunset on a Fuji digital SLR at f22, using a graduated neutral density filter to balance the sky with the ground. The exposure was 15 seconds, causing the seaweed to blur as it moved around on the surface of the water during the exposure.

## enhance

There was too much dead space at the top of the image, so it was split evenly between land and sky. The Crop tool was used to remove the sky and move up the horizon.

**1/** The original image features very flat colours and no contrast – it was a very disappointing sunset, despite the sky being very clear.

**2/** Tonal range was increased.

**3/** Hue was adjusted to introduce more purple.

**4/** The Unsharp Mask filter was run.

**5/** Curves was adjusted to add contrast.

**6/** The final version features a sky with a hue shift, sharpened rocks and enhanced contrast.

### 2  levels

Channel: RGB
Input Levels: 0  1.00  166

OK
Reset
Load...
Save...
Auto
Options...

☑ Preview

Output Levels: 0  255

The Levels function was used to increase the tonal range of the image (2). The Dodge tool was then used on the rocks to pick out some more detail in them.

The sky was selected with the Magic Wand selection tool and the Hue/Saturation control used to shift the hue to introduce purple into the sky (3). The selection was removed and the overall saturation increased.

### 3  hue saturation

Edit: Cyans

Hue: +24
Saturation: 0
Lightness: 0

OK
Reset
Load...
Save...

☐ Colorize
☑ Preview

164°/194°    224°\254°

### 4  unsharp mask

OK
Reset
☑ Preview

⊟ 100% ⊞

Amount: 100 %
Radius: 3.0 pixels
Threshold: 3 levels

> digital capture
> crop
> levels
> dodge tool
> hue/saturation
> unsharp mask
> dodge
> curves

! For the best type of lighthouse shots, wait until the light is on and rotating, then capture it as it goes around.

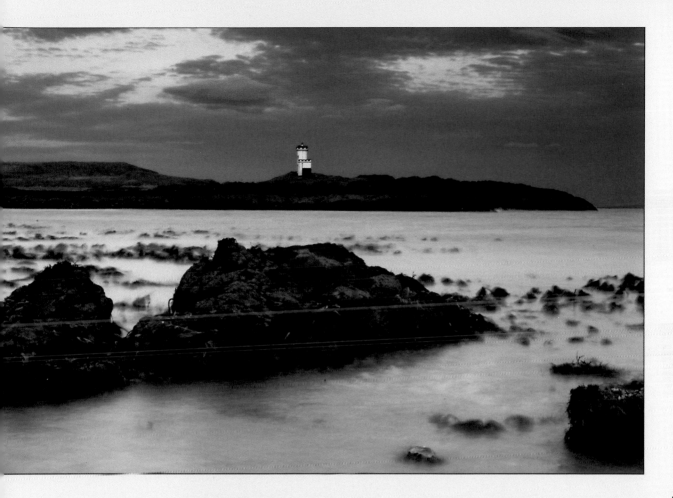

The distant land mass and the foreground rocks were then selected and feathered by 10 pixels. Afterwards, the Unsharp Mask filter was run using Amount: 100%, Radius: 3 pixels, Threshold: 3 settings (4).

The Dodge tool was used on the lighthouse to brighten it up a little and a final Curves adjustment was used to add contrast to the scene (5).

## 5  curves

! **Use a standard neutral density filter to slow the shutter speed even further so that the water is rendered as a blur.**

## enjoy

The image was resized to 640 pixels along the horizontal plane and then sharpened for use on my website: www.duncanevans.co.uk. It was also converted to CMYK and the contrast slightly increased for use in this book. I also added a border to the image using the pale shade of cyan that was in the water.

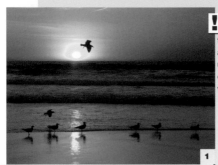

! If shooting into the sun, the camera will set the exposure for the brightest element, turning anything else into a shadow. Don't use spot metering on these kinds of objects because the background will always burn out as a result.

! If you want to highlight someone standing against a bright background like the one in this image, use fill-in flash to balance the exposure.

# beach scenes

As the tourists and locals make their way home, the evening sun lights up the beach and the birds descend to pick whatever the tide has to offer. For the photographer, the attractions are those of a pleasing sunset over the waves, the reflections on the wet sand and the presence of wildlife to add foreground interest. With bright lighting in the distance, it's inevitable that the birds will be rendered as dark outlines.

## shoot

This picture was taken at Guincho beach near Cascais in Portugal by Jorge Coimbra. He took it with a Canon high-spec digital compact with a built-in 35–140mm equivalent lens. The camera features a pop-out LCD that twists, so Jorge was able to use it to get exactly the composition he wanted, without having to look directly into the setting sun.

### 2 crop

**1/** The original image format was more square due to the CCD shape; it also had some minor imperfections.

**2/** The image was cropped to a rectangular shape.

**3/** Aeroplane trails and flare were removed.

**4/** Unsharp Mask was used to sharpen the image.

**5/** Contrast was increased using the Curves function.

**6/** The completed image is now a true landscape format; it has been tweaked and the aeroplane trails have been removed.

### 3 clone tool

## enhance

Crop was used to provide a rectangular landscape shape, and also to remove some of the aeroplane trail (2).

The Clone Stamp tool was then used to erase the remainder of the aeroplane trail and flare in the water, plus a small boat on the horizon (3).

The Unsharp Mask filter was applied to sharpen the image. The two flying seagulls were then selected with the Freehand Lasso and the Unsharp Mask applied to them as well (4).

Finally, the Curves function was used to increase the contrast and the strength of the colour effect (5).

### 4 unsharp mask

OK
Reset
☑ Preview

– 25% +

Amount: 75 %

Radius: 3.0 pixels

Threshold: 3 levels

### 5 curves

Channel: RGB

OK
Cancel
Load...
Save...
Smooth
Auto
Options...

Input: 65
Output: 57

☑ Preview

> digital capture
> crop
> clone stamp
> unsharp mask
> selection
> unsharp mask
> curves
> save for web

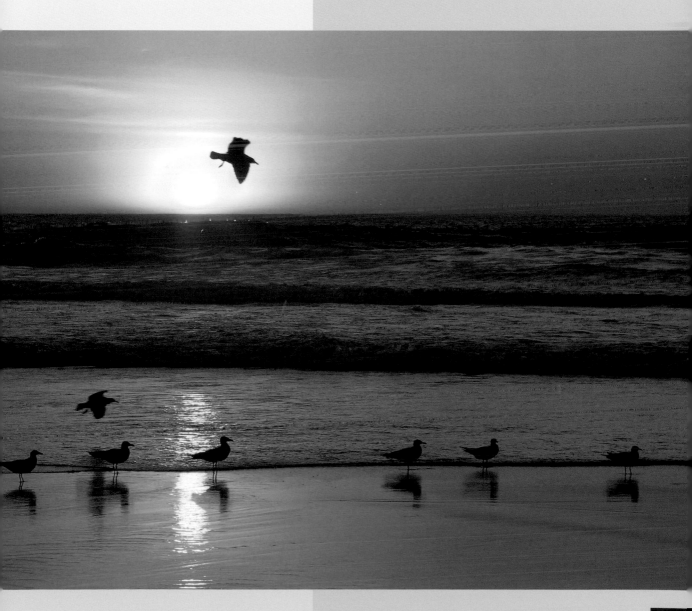

! When shooting fairly bland surfaces – like the sea at a beach – try to capture additional elements that will add interest. In this picture, it is the inclusion of birds that makes it worthwhile.

## enjoy

Jorge makes prints for his own enjoyment, though some have been printed in books and magazines. For web use he usually adjusts the image size down and saves at 150K, which provides acceptable JPEG quality.

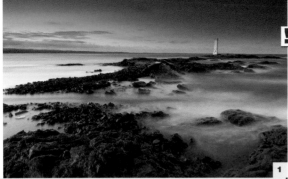

# using filters

In this day and age of digital manipulation it can seem anachronistic to champion the use of filters on digital cameras, but certain ones are just as useful as they have ever been. Digital cameras don't have the best tonal range and don't produce fantastic colours; you can enhance and help the camera by using the right filters to create specific effects, particularly in low-light conditions.

## shoot

Marcio Cabral of Brazil was outside the city of Itacare, waiting for the sunset. Unfortunately, the colours were disappointing so he fitted a graduating filter called Sunset 1 to his Nikon digital SLR, with a Nikon 12–24mm f4 DX lens. The stormy sea was pounding over the rocks, which made it ideal for a long exposure. Marcio fitted a two-stop neutral density filter to reduce the light coming into the camera and lengthen the shutter speed for a long exposure.

## enhance

Marcio was faced with a high contrast scene and so decided to take two pictures of it: one slightly underexposed, the other overexposed, so that the highlights and the shadows would have enough detail. He then loaded them both into Photoshop (2).

A layer mask was added to the top layer and this was painted with black in the sky area to mask it. This blocked it off, allowing the darker sky and the lighter land to be merged together (3).

The layers were merged and Brightness/Contrast used to boost the lightness and contrast (4).

**1/** Use of filters at the capture stage can give you images that are difficult to create entirely in Photoshop. Even so, Marcio decided to make two exposures as he felt this one was too flat.

**2/** Two images were loaded in Photoshop.

**3/** A layer mask was added to the top layer.

**4/** Lightness and contrast were enhanced using Brightness/Contrast.

**5/** After merging two different exposures and tweaking the contrast, the full tonal range of the original scene is revealed in the final image.

> digital capture x2
> layer mask
> paint
> layer merge
> brightness/contrast
> web size plug-in

**2** loaded images

**3** layer mask

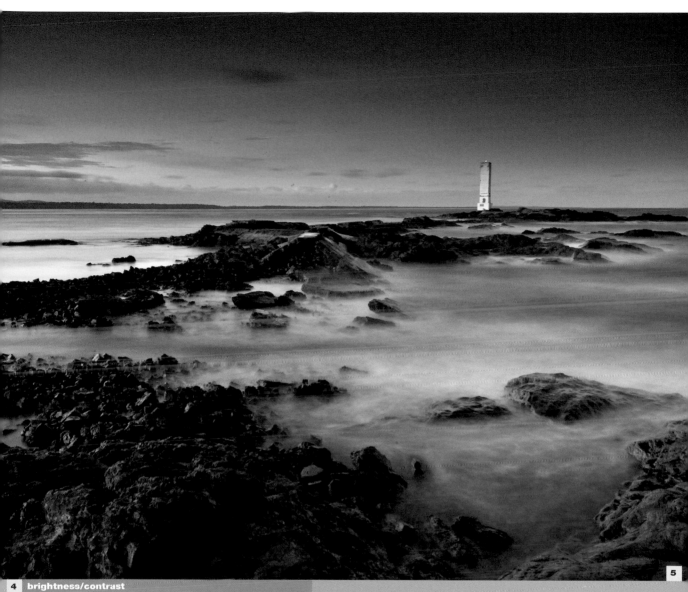

5

## 4 brightness/contrast

Brightness: +4

OK

Cancel

Contrast: +13

☑ Preview

**!** **A polariser can be used to block reflections on water (or other reflective surfaces) or to maximise them. It can also darken sky colours rather than deepen them, as with film, but be aware that most polarisers also stop between one and two stops of light entering the camera.**

## enjoy

Marcio takes pictures with commercial purposes in mind. In general, he sells the images to nature magazines, travel guides, tourist agencies, and submits them to photo contests. His web pictures are prepared using Fred Miranda Web Presenter to reduce the size.

**!** To record traffic and people rushing by as a blur, but still maintain sharp-looking buildings, use a tripod and the maximum f-stop on the camera.

**!** To freeze people rushing about, but with trails of blur, use second curtain flash as well as the long exposure.

# city lights

The heart of the city beats to a different rhythm than anywhere else. The city bursts with neon colour, car trails, and hurried, excited, miserable faces everywhere. Photographically, the city centres come alive after dark, both in terms of the people and the lighting. If it rains as well, then you are blessed with reflective puddles and wet concrete suddenly imbued with dark contrast. Get in amongst the hustle and bustle and capture those city lights.

## shoot

Steven Rosen of Brooklyn, New York, USA was in Times Square because one of his photos had won the Kodak photo of the day contest. Everyday the winner was displayed on the Kodak Jumbotron screen in Times Square, so he was there to record it. He took a shot that showed the winning picture, but the best of the night-time pictures showed a different image as they rotated through a sequence. He shot these with a Canon digital SLR using a Canon 18–55mm short zoom lens.

### 3 paste layer

### 4 eraser

## enhance

The area of the winning picture was selected and copied. It was then pasted as a new layer on to the composite picture. The Distort option was used to size it to fit over the existing photo on the Kodak sign (3).

The unnecessary area around the new picture was then erased (4).

Curves was used to brighten the picture in general. A duplicate layer was created and the Shadow/Highlight tool used to bring out more details in the shadows.

The Curves function was run to brighten the image some more, but this time a layer mask was added. A black-to-white gradient was added to

### 5 curves

Channel: RGB

OK
Reset
Load...
Save...
Smooth
Auto
Options...

Input : 108
Output : 144

☑ Preview

**1/** The original image of Times Square by Steven Rosen is dark and didn't show his winning picture.

**2/** The winning picture (gondolier in Venice) was present on a different, but pictorially poor image.

**3/** The winning picture was pasted as a new layer on to the composite picture.

**4/** Unnecessary areas were erased.

**5/** The image was brightened and details brought out in the shadows using Curves.

**6/** A layer mask was added to retain some of the highlights.

**7/** Perspective was used to straighten the buildings.

**8/** Saturation was increased.

**9/** After a spot of composition and tweaking, here's a great city lights picture, plus for Steven, his winning picture.

### 6 layer mask

> digital capture

> select, copy, paste

> distort

> erase

> curves

> shadow/highlight

> curves with gradient mask

> perspective transform

> hue/saturation

> save for web

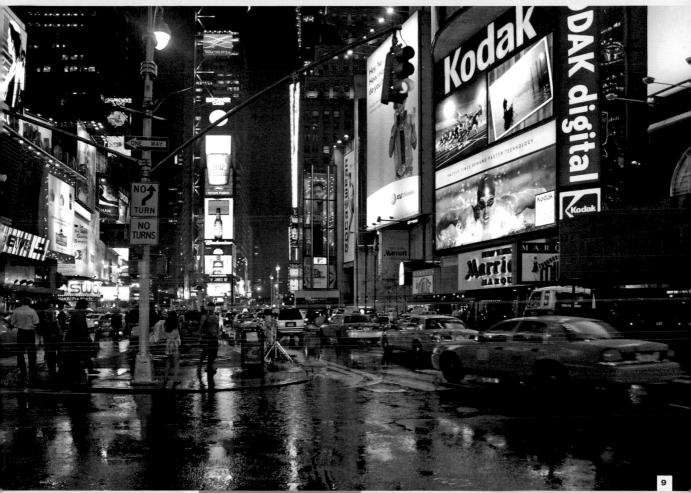

9

the mask to retain the highlights at the top of the picture and exposed the bottom of the picture, which had been brightened (5/6).

The layers were merged and then a new duplicate layer was created. This was selected and then the Perspective option of the Transform menu entry was used to straighten the converging verticals of the buildings (7).

Finally, the saturation was increased with the Hue/Saturation control (8).

7 **perspective**

**!** **Don't set the camera to auto and use flash, the result will be a tourist snap. For really far-out images, get in a taxi and record a long exposure out of the window as you drive.**

8 **hue/saturation**

## enjoy

Steven started out by making prints for himself, but his goal now is to sell his images. When he prepares images for web use, he uses the Save for Web function in Photoshop to optimise file size and resolution. This image was converted to CMYK for this book, which was a little tricky with all the neon colours, so the contrast had to be increased.

> Use an aperture setting with enough depth of field to ensure the background is reasonably sharp. If the background is all along a flat plane then you can get away with an aperture of f4.

**1**

# fireworks

One of the most impressive sights to capture photographically is a fireworks display. Town or city organised fireworks are held on a much larger scale and usually set against a backdrop of city features or architecture, such as skyscrapers.

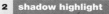
## shoot

Steven Rosen of New York, USA had a ringside seat for the Fourth of July city celebrations as the terrace of his apartment overlooked where the fireworks were being set off. He set up his Canon digital SLR with an 18–55mm lens and set the exposure to 1/4th of a sec at an aperture of f10. He also cranked the ISO up to 800 in order to be able to use an aperture setting that would give good depth of field and ensure that the buildings behind the fireworks retained some sharpness.

**2** shadow highlight

## enhance

The Shadow/Highlight filter was used to bring out the details in the buildings and shadow areas (2).

The Hue/Saturation control was used to increase the saturation in the picture by 20% (3).

A duplicate layer was then created and the Transform tool used to straighten out the horizon (4).

> The longer the shutter speed, the more trails will be recorded. If the fireworks are spaced out, try to get a 15-second exposure to record lots of activity.

**3** hue/saturation

Edit: Master

Hue: 0

Saturation: +20

Lightness: 0

OK
Cancel
Load...
Save...

Colorize
Preview

> Experiment with the settings for the best result. Each display will create a different amount of light to record against the backdrop.

> digital capture
> shadow/highlight
> hue/saturation
> transform

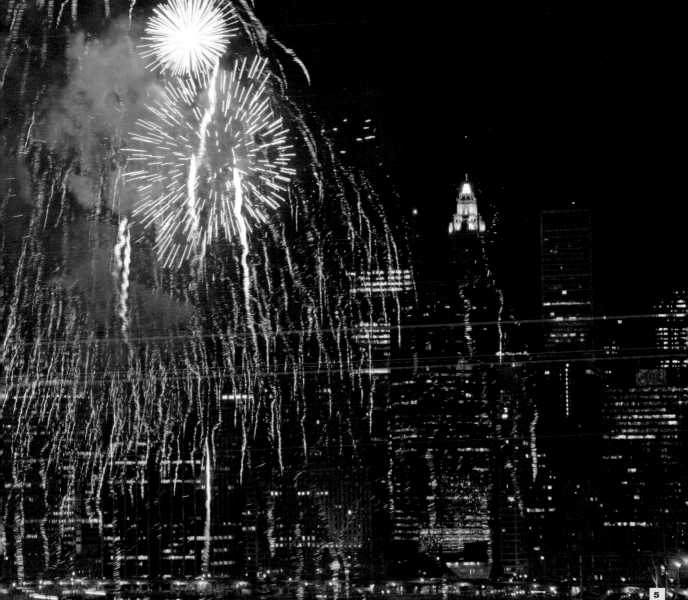

**4** transform

**1/** The original image is a little dark, but this ensured that detail in the fireworks was not lost.

**2/** Details in dark areas were brought out using the Shadow/Highlight filter.

**3/** The saturation was increased by 20%.

**4/** The horizon was straightened with the Transform tool.

**5/** After a few tweaks, the fireworks are revealed, set against the backdrop of New York city.

### enjoy

Steven takes photos with the aim of selling them so that while he still produces prints for himself, it is usually with a commercial audience in mind. To use smaller versions of images on his website, he uses the Photoshop Save for Web function.

! You should try to get as much depth of field as possible. With the camera doing the metering, increase the aperture setting until you reach the maximum length of shutter speed the camera can produce.

! Unless the bridge is quite close, manually set the focus to infinity as the autofocus can have problems in the dark.

**1/** The original image has distortion, and is exposed to ensure detail is kept in the lights, hence the background is very dark.

**2/** The verticals were straightened using Transform.

**3/** Levels was applied to brighten the image.

**4/** Detail was restored using a mask.

**5/** Saturation was increased for reds, blues and yellows.

# bridges and reflections

As it gets dark, reflections from lights and cars on bridges over water become more noticeable and photogenic. Getting the exposure right for night shots is tricky, but it should be centred around capturing detail in the lights, not the background. The dark areas can be lightened afterwards – burnt out detail in lights is much harder to fix.

## shoot

This is the Forth Rail bridge that takes trains from Fife towards Edinburgh in Scotland. A 27mm wide-angle lens was used to capture the scene on a Fuji digital SLR, though this lead to some distortion in the picture. An aperture of f9.5 was used to get reasonable depth of field, while the exposure time of 15 seconds ensured the lights were captured without losing detail. As the viewpoint was in the opposite direction to the sunset, the sky was very dark and thus required post-production work to make it more interesting.

## enhance

The first task was to straighten the verticals out, particularly of the bridge support on the left. The image was selected then Edit > Distort used to straighten the left side and pull the image up as the process tends to squash it (2).

**2** transform

**3 levels**

The Crop tool was also used to remove some of the distracting muddy areas at the bottom of the picture.

A Levels adjustment layer was then created. The Levels were adjusted so that the image became a great deal brighter, bringing back some blue colour into the sky (3).

**4 mask**

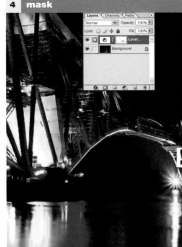

**5 hue/saturation**

The Paintbrush was then selected and a 20% Opacity black brush was used to paint on the mask so that detail was restored to the burnt-out areas of the lights and bridge struts (4). The layers were then merged.

The Hue/Saturation control was used to increase the saturation for individual components of red, yellow and blue parts of the picture (5).

> digital capture

> distort

> crop

> levels adjustment layer

> hue/saturation

> curves

> magic wand

> gaussian blur

> unsharp mask

> resize for web use

> convert to CMYK

! If your camera has a Bulb setting, then you can work out even longer exposures. As you increase the aperture by one f-stop, double the exposure time. So, to go from f8 at 15 seconds, you can use f11 at 30 seconds, f16 at 60 seconds and f22 at 120 seconds.

To lighten the bridgework and a little of the sky without affecting the highlights and shadows, the Curves function was run. Control points at the top and bottom of the Curves line held those elements in place while the midtones were brightened (6).

Increasing the brightness of dark images invariably increases the noise

## curves

Channel: RGB

OK
Reset
Load...
Save...
Smooth
Auto
Options...

Input : 101
Output : 116

☑ Preview

## gaussian blur

OK
Reset

☑ Preview

☐ 100% ☐

Radius: 2 pixels

**6/** Curves was used to brighten some elements.

**7/** Digital noise was reduced using the Gaussian Blur filter.

**8/** The bridge was sharpened using the Unsharp Mask filter.

**9/** After straightening and colour and brightness correction, the scene is much more attractive.

## enjoy

The image was reduced to 500 pixels along with horizontal dimension and the file size reduced to under 100K for display on the online folio pages of the Digital Imaging Group of the Royal Photographic Society. It was sharpened after resizing. For use in the book it presented a few problems because the colours are so vivid. After conversion to CMYK, the reds were particularly affected as CMYK does not have any bright colours in its colour gamut. The contrast was increased, but the RGB version is still superior.

so the Magic Wand was selected with a Tolerance of 20%. The sky and the main parts of it visible through the bridge were selected and added to the selection by holding down the Shift key. The selection was feathered by one pixel and then the Gaussian Blur filter run at two pixels to smooth out the noise (7).

The selection was then inverted and the Unsharp Mask filter was used with settings of, Amount: 50%, Radius: 3 pixels, Threshold: 3 levels to sharpen the bridge (8).

## unsharp mask

OK
Reset

☑ Preview

☐ 100% ☐

Amount: 50 %
Radius: 3.0 pixels
Threshold: 3 levels

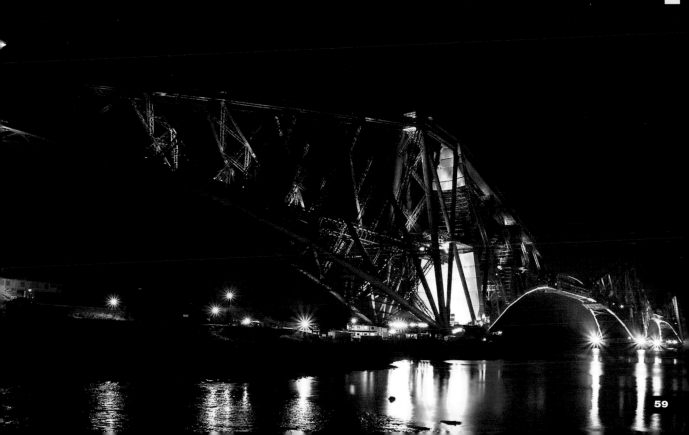

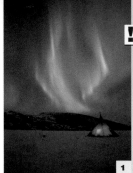

**!** Sunspot activity is often a precursor to pyrotechnics in the atmosphere. Listen to news forecasts advising of such activity.

**!** Some foreground interest is advisable in your shots so try to use as narrow an aperture setting as you can, pushing the camera up to the limit of how long it can record for.

**!** Experiment with a number of different white balance settings as the camera may well try to cancel the colour out. Take a number of shots to ensure you get ones with good colour.

1

# northern lights

The combination of solar radiation and the earth's upper atmosphere can result in impressive sheets of wafting colour called the Aurora Borealis, or Northern Lights. The nearer you get to either of the earth's poles, the more likely you are to see the effect. Capturing it on digital camera requires a long exposure, but as it isn't black, the time required is within the parameters of most digital SLRs.

## shoot

Eskil Olsen of Skonseng in northern Norway was camping with his fiancée on a frozen lake called Langvatnet, near Mo i Rana. It was past midnight and the temperature was -22 degrees Celsius when Eskil spotted the light show overhead. He ran outside in his underwear, armed with an 11Mp Canon professional SLR and snapped off as many shots as he could. The aperture for this shot was f4, giving an exposure time of 15 seconds.

**2 RAW**

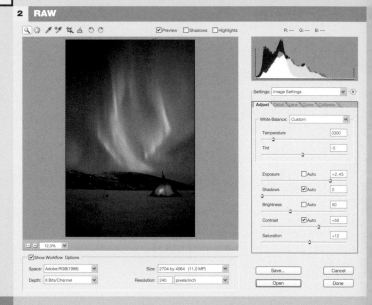

**3 crop**

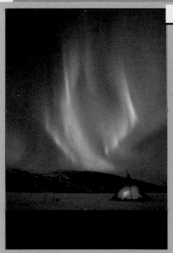

## enhance

The original image was shot using the Canon RAW format so the first task was to convert it to a TIFF and adjust the saturation (2).

Once imported into Photoshop CS, the image was straightened (the perspective altered due to the use of a wide angle lens) and cropped to remove the blank area at the bottom of the image (3).

The Levels were then adjusted to give the image more contrast and life, and to use the entire tonal range available (4).

After cloning out a few dust spots, a plug-in filter was used to reduce the noise in the image from the long exposure (5).

> digital capture
> RAW image processing
> straighten
> crop
> levels
> clone
> noise reduction

**1/** Shivering in the sub-zero temperatures, Eskil Olsen managed to capture this amazing shot of the Northern Lights.

**2/** The original image was saved in RAW format.

**3/** The image was straightened and cropped.

**4/** Contrast was increased using Levels.

**5/** A plug-in filter was used to reduce noise.

**6/** After cropping and tweaking the contrast, the lights are revealed in all their glory.

**4 levels**

Channel: RGB

Input Levels: 0 1.00 198

OK
Reset
Load...
Save...
Auto
Options

Output Levels: 0 255

**5 plug-in filter**

Filter  View  Window  Help

| Last Filter | Ctrl+F |
| Extract... | Alt+Ctrl+X |
| Filter Gallery... | |
| Liquify... | Shift+Ctrl+X |
| Pattern Maker... | Alt+Shift+Ctrl+X |
| Artistic | ▶ |
| Blur | ▶ |
| Brush Strokes | ▶ |
| Distort | ▶ |
| Noise | ▶ |
| Pixelate | ▶ |
| Render | ▶ |
| Sharpen | ▶ |
| Sketch | ▶ |
| Stylize | ▶ |
| Texture | ▶ |
| Video | ▶ |
| Other | ▶ |
| Digimarc | ▶ |
| ePaperPress | ▶ |
| Nest Image | ▶ | Reduce Noise... |
| Phase One A/S | ▶ |
| xero | ▶ |

6

**enjoy**

Eskil makes prints of his photos to sell. This image will be used as an advertisement for Norway on the VisitNorway.com website, and will be printed as large as 50cm x 70cm.

The Norwegian name of the picture is Nordlysnatt, which means 'Mysterious Lights', and it has already won a number of photography competitions.

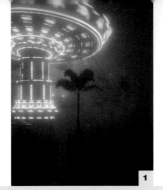

1

! Don't use regular flash as this will kill the atmosphere. However, if shooting people with the fairground as a background, use fill-in flash or second curtain flash on a long exposure to combine both person and background.

! Capturing the action without flash, particularly at night, will require a higher ISO rating, most likely of 800. However, if you have a lens with an aperture of f1.8 you will be able to use a lower ISO.

# fairground attractions

If there's one place at night where you can guarantee a profusion of colour, light and people, it's at a fairground. The rides are invariably festooned with glowing neon lights and the people throng around them looking for inexpensive thrills and entertainment. How you tackle the opportunity is down to you, but a long exposure shot, mounted on a tripod or available solid surface, will enable you to blur lights and people while retaining form and structure, which is what we have with this image.

## shoot

Kenny Goh of Kuala Lumpur in Malaysia shot this image at the Genting Highlands in the state of Pahang, Malaysia. Genting Highlands is a famous international tourist location featuring hotels, casinos, and indoor and outdoor entertainment facilities. This shot was taken in the evening at the giant carousel ride when a low cloud blew across the park. As it was already wet, it resulted in reflections and a misty aspect. Kenny had his Nikon digital camera set up on a tripod and shot the image at a slow 1/7th of a sec exposure, which gave the carousel time to blur the lights, but not enough for the crowds to move very much.

## enhance

While Kenny aimed to get the picture to be as perfect as possible in-camera, it was saved as a JPEG in a horizontal orientation. The first step was simply to rotate it and save it as a TIFF.

A Curves function was used to darken the shadows and enhance the lights. This was done by using

2  curves

3  hue/saturation

4  contrast

the standard S-shape on the curve, where the middle control carat holds the midtones in place (2).

The saturation was increased to bring out the colours more by using the Hue/Saturation slide (3). The yellow band of colours was selected and the saturation increased by 20%.

The image was then converted to CMYK for printing in this book. As this knocked back the colours, the contrast was increased to compensate (4).

## enjoy

Kenny uses the sRGB colour space as a matter of course because his printing equipment uses it; this retains the colours without any loss during conversion. He produces prints for his own interest as well as

for the occasional public exhibition in Malaysia. For printing, a large, black border was added to the image along with Kenny's web address and email details.

> digital capture
> rotation
> curves
> hue/saturation
> CMYK
> contrast
> border

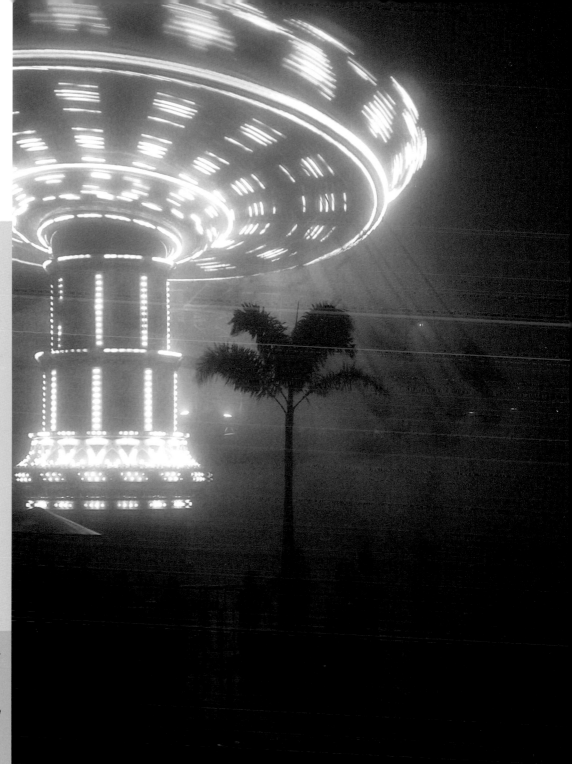

**1/** Shot from a sideways angle, the original, atmospheric image has been rotated for use here.

**2/** Shadows were darkened and lights enhanced using Curves.

**3/** Saturation was increased to bring out colours.

**4/** The contrast was increased.

**5/** After a few tweaks to compensate for conversion to CMYK for printing, the fairground carousel spins away in all its glory.

**Experiment with settings. Using front curtain flash will capture the scene at the start of the exposure, but then also capture the movement that takes place afterwards giving a brash, surreal aspect to the shot.**

5

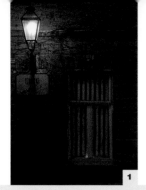

1

! Don't worry about depth of field when using a compact under low light conditions. Compact digital cameras have up to five times as much depth of field as a traditional 35mm film camera at the same aperture.

! Shutter speed is everything in shots like this. The wider the angle of the lens, the slower the shutter speed you can use with the camera hand-held. Anything under 1/8th of a sec either needs to be held against a wall or mounted on a tripod, no matter how wide the lens angle.

# street lamps

Street lamps are antiquated, archaic sources of lighting – or at least that's what they look like. At one time they may have been powered by gas, but these days almost all are powered by electricity and use tungsten bulbs. The point, however, is that they produce a low-power glow, and their holding devices are wonderfully ornate and aesthetically pleasing. These kinds of things aren't used to light motorways, so look around and see what kind of urban scenery they are being used to light.

> digital capture
> rotate
> crop
> fill-in flash
> selection
> levels
> unsharp mask
> clone stamp
> noise removal

## shoot

Mirko Sorak from Zagreb in Croatia shot this image with a high-spec Nikon compact camera. The shot was taken in Zagreb as it showed an interesting mixture of textures, combined with the pleasant glow of the tungsten light. Mirko also felt that the window was interesting and added contrast to the whole scene. The exposure was slow – a second; this would have required a tripod, but fill-in flash was used instead. An aperture of f4.8 gave enough depth of field as the scene is quite shallow.

## enhance

First, the original landscape-orientated capture was rotated 90 degrees anti-clockwise. Then the Crop tool was used to make the contents more symmetrical and tightly composed (2).

The lamp was selected with the Polygonal Lasso tool. This was feathered by 100 pixels and then inverted to select the rest of the picture. Next, the Levels control was used to bring out the details in the wall (3).

### 4  unsharp mask

The Unsharp Mask filter was applied to sharpen the image, and to also add a subtle amount of contrast (4). The settings were Amount: 30, Radius: 50, Threshold: 2.

Finally, the Clone Stamp tool was used to remove some distracting objects from the photo and the reflection from the flash in the window (5). A third-party filter was used to clean up some of the noise now apparent in the image.

### 2  crop

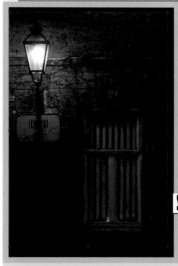

### 3  levels

! Experiment with different white balance settings and check them on the computer later for the one that is most pleasing.

### 5  clone stamp

Mirko makes a number of prints as today's printers aren't that expensive and produce high-quality images for a good price. He sells a few photos to some commercial clients. When posting photos on the Web, Mirko usually resizes a picture to 650 pixels on the longer side and applies a touch of Unsharp Mask to restore some of the bite lost by reducing the image size.

**1/** The original image is flat and the rest of the scene is underexposed thanks to the brightness of the lamp.

**2/** The Crop tool was used to tighten the composition.

**3/** The lamp was selected and details on the wall highlighted using Levels.

**4/** Unsharp Mask was used for sharpening and providing contrast.

**5/** The Clone Stamp tool was applied to remove distracting elements.

**6/** The final atmospheric image with more detail.

6

# 5  in dark places

This chapter is about places where the light is very restricted, dark or gloomy. It covers unlit rooms, shadowy forests, church interiors and working by window light alone. There is no artificial light here, it's all natural, but at a very low level. The results are dark and enticing with a sense of mystery, serenity and quiet.

Jeffrey Kubach of Los Angeles, USA shot this photo with a Panasonic compact digital camera, hand-held at the bar in the W Hotel in Times Square, New York.

Jeff says, 'My instincts play a bigger role than any formal training I've had. I usually take photos when I feel a certain mood about the environment I'm in, hopefully capturing the lighting, colour and composition. Photoshop was used to crop the image and make the colours more vivid.'

photographers

Jeffrey Kubach
Marion Luijten
Duncan Evans
Kenvin Pinardy
Felipe Rodriguez

# window light

Light from a window can be one of the most atmospheric lighting devices to use, as long as it isn't strong sunshine. Net curtains at the window can diffuse the light, offering soft, flattering light for a subject. It's even better if the subject is actually going about their daily business – you then have the opportunity to capture them in atmospheric lighting.

## shoot

Marion Luijten of Oisterwijk, the Netherlands, was on holiday with her daughter in Cuba when they went to see an official cigar-making factory. One of the workers invited them back to his house, where the worker's brother was engaged in his own cigar-making operation. Marion saw the soft, gentle light from the window, set the aperture on her Sony prosumer compact to f2 and held still for the 1/30th of a sec exposure.

**2 crop**

**3 curves**

## enhance

The first step was to crop the image to remove some spare area around the edges (2).

Curves was then used to brighten the image by moving the mid-point to the left. This created an upwards curve, brightening the image through the range (3).

The tones in the image were then spread out a little more by using Levels. The right carat on the Input was moved to the left. This moved the range of tones towards the lighter end (4).

**4 levels**

> digital capture
> crop
> curves
> levels

**!** It may be that the interior is very dark and only the window area is light. In which case, light levels will be low so you may need to use a wide aperture. If the shutter speed falls too low, consider using a higher ISO rating if a tripod isn't available.

Marion uses an Epson Stylus 2100 A3+ photo printer for her larger prints. She always prints on matte paper rather than gloss for a more natural finish. She prints for exhibitions, contests and reviews at her photography club. She also prints work for commercial and sales purposes.

**1/** In the original image, Marion saw the potential offered by the window light and braced herself for this low light shot.

**2/** The image was cropped to focus on the subject.

**3/** Curves was applied to brighten the image.

**4/** The tones in the image were spread out.

**5/** After some subtle adjustments the image now shows the soft, casual window light, illuminating a home worker at his craft.

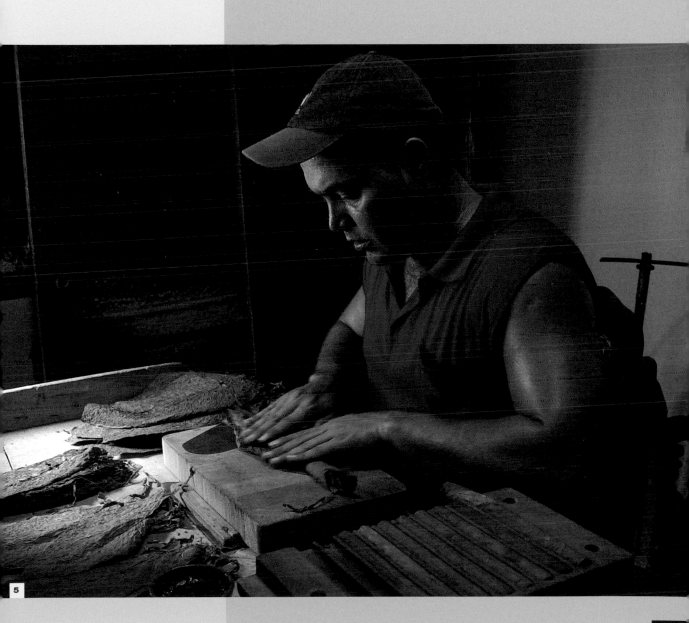

5

This is Deil's Cauldron in Strathearn, Scotland, where a fast-flowing forest stream finds itself completely undercover at this point. Being a dark location, there is a lot of green undergrowth and lichen-covered bark. This was a dreary day, but under the canopy, the exterior conditions were irrelevant. The photo was shot on a Fuji digital SLR with a 17–35mm (25–52mm equivalent) wide-angle Sigma lens. With an aperture of f22, the shutter speed was a lengthy 15 seconds, which turned the tumbling water into a smooth flow.

**!** You want to get 15 to 30 seconds of exposure to really blur the water, so if it is still too light to achieve that using the maximum aperture of the camera, use a polariser or ND filters to drop the light level down another couple of stops.

1

# forest rivers and streams

If the weather or bright lighting conditions let you down, enter the world of the forest river or stream. With the heavy canopy of greenery, you'll be protected from the rain, the listless sky is hidden, making the low light levels perfect for long-exposure photography. Blurred, flowing water shots in the middle of the day are suddenly possible and rainy days are no longer a washout.

## enhance

Having been captured digitally the original image was slightly flat, but full of green colour. First, a duplicate layer was created and then the Gaussian Blur filter applied at a strength of 50 pixels (2). This completely blurred the layer.

However, the layer Blend Mode was set to Hard Light, which gave the overall impression of richer, darker, colours (3), with a subtle ghosting effect.

The effect was overdone in certain areas like the rocks and water. To solve this, a layer mask was added to the blurred layer. Using the Paintbrush tool set at 33% Opacity, with black as the foreground colour, the mask was painted over to block the layer and reduce the strength of the effect (4).

The layers were merged and the Burn and Dodge tools used at 4% exposure to selectively darken tree trunks in the distance and lighten areas of rock in the foreground.

A small crop was applied to trim the woodland at the top of the image (5). It was then interpolated slightly to restore the size to 3000 pixels vertically.

4 **mask**

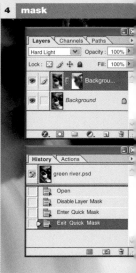

> digital capture

> duplicate layer

> gaussian blur

> hard light blend mode

> layer mask

> paintbrush

> burn and dodge

> crop

> interpolation

> save as RGB

> convert to CMYK

2 **gaussian blur**

OK
Cancel
☑ Preview

— 100% +

Radius: 50.0 pixels

**!** A tripod is essential for shooting in the woods, but boots with a good grip are also useful, since the forest floor may be muddy or slippery.

3 **blend mode**

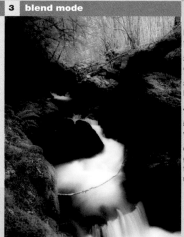

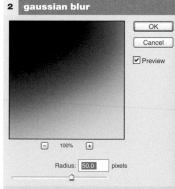

**1/** Under thick foliage, this long-exposure shot could be taken in the middle of the day.

**2/** Gaussian blur was applied to a duplicate layer.

**3/** Blend Mode was set to Hard Light.

**4/** A layer mask was added.

**5/** The top of the image was trimmed.

**6/** The image was manipulated to give a subtle ghosting effect and the contrast was enhanced to make it more vivid.

## enjoy

For use in this book the image was converted to CMYK. However, the colour gamut of CMYK is nothing like the original RGB that the image was prepared in. As a result, the Hue/saturation control had to be used to shift some of the green hues towards yellow and away from blue, in order for the CMYK version to bear some relation to the RGB version.

**5** crop

6

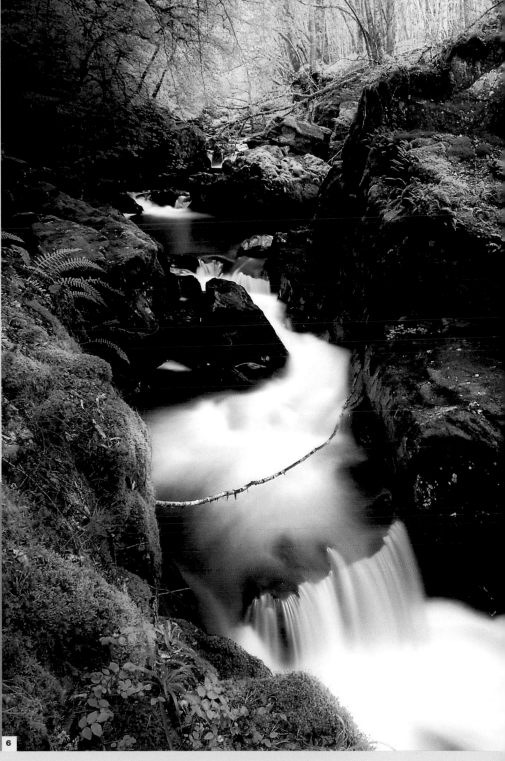

**1**

! When shooting in darkened conditions like this, focusing may be difficult and the autofocus can be fooled. Take a couple of shots and then use manual focus for a few more to ensure that you have a sharp image.

! Use a wide open aperture to give you enough shutter speed to shoot hand-held. If the shutter speed falls below 1/30th of a sec, use a tripod instead of increasing the ISO rating.

# moonlight

Shooting a subject in a darkened room where the only light is coming through a window has a distinct advantage. Since the light source is not immediately obvious, it can be digitally toned or coloured so that it looks like a golden morning, a blazing evening or, as with this shot, a moonlit night.

## shoot

This image was shot by Kenvin Pinardy of Jakarta, Indonesia, using a Canon digital SLR and a Canon 50mm f1.8 portrait lens. He shot it with a virtually wide-open aperture of f2 so that the figure was sharp. However, depth of field was short and focus rapidly disappeared in the background.
It was shot in a 100-year-old building in the centre of Jakarta, as Kenvin wanted to create an image with plenty of atmosphere.

## enhance

First, the Levels were adjusted to allow for more contrast and deeper shadows (2).

The Colour Balance function was then used to tone the image so that it was bluer and more like the colour of moonlight (3).

Areas like the tiles on the floor were lightened with the Dodge tool to reflect the moonlight effect, and other areas were darkened with the Burn tool (4).

The Unsharp Mask filter was then used as the subject wasn't very sharp.

**2 levels**

**3 colour balance**

**4 dodge**

**5 unsharp mask**

> digital capture
> levels
> colour balance
> dodge
> burn
> unsharp mask

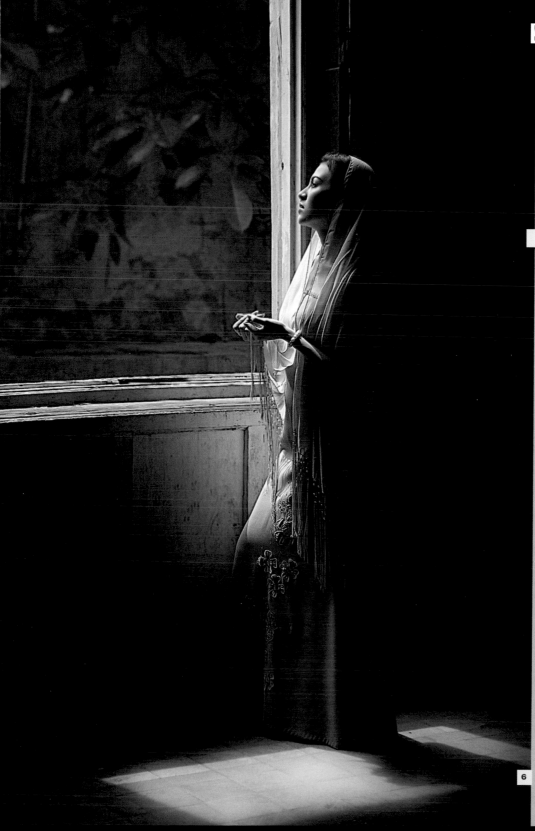

<span style="border:1px solid black; padding:2px;">!</span> **Use Colour Balance and Hue/Saturation, or even Variations, to add colour and tone to your image – making it look like it was taken at different times of the day.**

## enjoy

Up until now, Kenvin has only made prints for his own enjoyment. He started off taking photos of still life and macro shots, but has since moved on to people shots and using models. The image was converted to CMYK for reproduction in this book.

**1/** The original image is fine in itself, but Kenvin wanted to create one with a special atmosphere.

**2/** Levels was used to boost contrast.

**3/** Colour Balance was applied to increase the blue tones in the image.

**4/** Selected areas were lightened or darkened.

**5/** The subject was sharpened using Unsharp Mask.

**6/** The final image is a very atmospheric photograph.

6

# churches at night

For sheer atmosphere, it's hard to beat shooting inside an old church or cathedral. There is a palpable sense of calm and serenity, on top of rich architecture which can be hundreds of years old. Add people, whether worshipping or simply visiting, and you have the perfect human-interest factor to relate to the cold, dark interior.

## shoot

Felipe Rodriguez of Seville, Spain, went on a trip to Verona, Italy, to visit the San Zeno Maggiore church. It's an impressive Romanesque building. It was evening when Felipe and his family visited, so the light was spectacular inside. Felipe carried a little tripod with him so that he could shoot with good depth of field and not worry about camera shake. This shot was taken from the choir position. He manually metered the light, and then adjusted the exposure using the histogram.

## 2 levels

## 3 transform

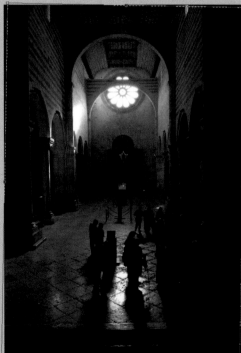

## enhance

The image was a little on the dark side. Once the RAW image had been converted, it was lightened slightly by using a Levels adjustment layer. The window was masked off to prevent burn out (2).

Despite using a tripod, the horizontal was slightly off so the Transform > Rotate option was used to straighten it up (3).

1/ The San Zeno Maggiore church caught in all its splendour by Felipe and his Nikon digital SLR with a 17–55mm DX lens.

2/ Levels was adjusted to add more brightness.

3/ The image was rotated slightly and straightened.

4/ As the shot was almost perfect the first time, there was little modification required to produce an atmospheric shot.

> digital capture
> RAW conversion
> levels
> transform > rotate

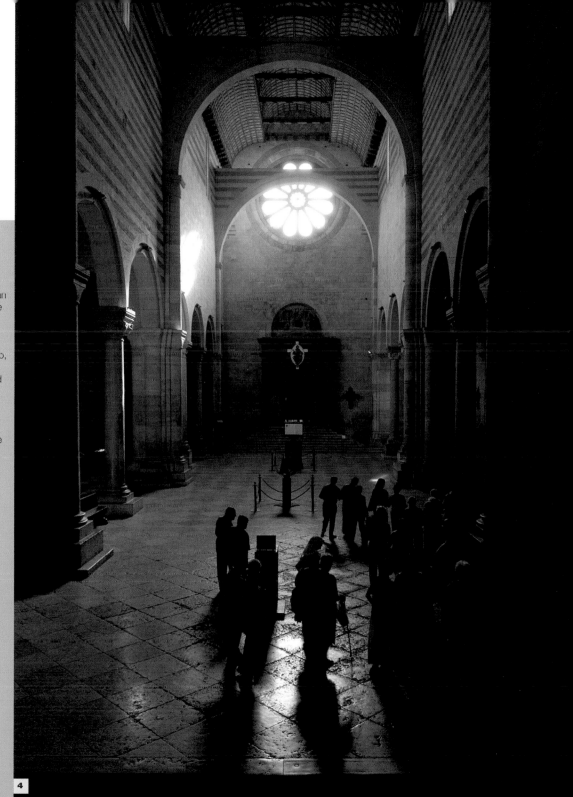

## enjoy

Felipe has printed this image for his own enjoyment and for use in an exhibition. For Web use he resized it to 600 x 400 pixels and then applied some sharpening. For colour pictures for the Web, he usually changes the colour space to sRGB and boosts the saturation slightly to compensate for the loss of colour gamut. The sRGB profile is better for the Web because more monitors will see the colours correctly.

# 6  capturing movement

Under extreme lighting conditions, you can do two things with movement. First, you can blur the subject while the background remains sharp. Second, anything that is moving quickly can be frozen. For most photographers, it's the ability to change how the moving object is depicted, while retaining the framework of the landscape, that is appealing. All you have to do is learn how to control the exposure.

Wilson Tsoi took this photo of his son, Felyx, at a waterfall on the island of Hawaii. He used a Canon compact digital camera and set it to the maximum aperture to get the longest shutter speed possible.

Wilson says, 'We hiked 30 minutes to a waterfall near Haiku and my children started bare-hand fishing. I followed Felyx around with a camera as he successfully caught little fishes on several occasions. I wanted to capture his stillness and concentration against a natural, serene Hawaiian scene. I wanted to get a low point of view, so instead of using a tripod, I placed the camera body on a half-submerged log and triggered the shutter hand-held, with two-second self-timer to avoid camera shake.'

**photographers**

Wilson Tsoi
Thomas McConville
Keith Saint
Sean McHugh
Paolo Corradini

> When shooting at night, don't rely on the LCD to gauge what the image will look like. The LCD presents a more high-contrast image, than what you've actually shot.

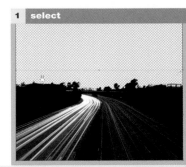

**1 select**

**2 select**

> Bulb or manual mode must be used to ensure good depth of field, as well as the long exposure. To work out the exposure, meter at f2.8 to get a shutter speed, then advance the aperture by one stop and double the time. Repeat this until you get the aperture you want – it should be f16 or f22.

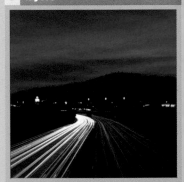

# car trails

Long after the sun has set, there is still a little colour left in the sky, creating the perfect moment for recording car trails. Since the exposure is a long one and the light level is so low, the cars only record as a faint blur, if at all. The tail and headlights on the other hand, are much brighter and record as trails of light. Match this to the lights of the city and you are on your way to creating a futuristic vista.

## shoot

Thomas McConville of Long Beach, California, shot this image with a Canon digital SLR and a Canon 180mm f3.5 lens for the sky and a 28–70mm lens for the highway and buildings. Thomas wanted to depict Los Angeles in the future, but to show the sheer energy and movement in the massive metropolis. As the skyscrapers are in a location that allows them to be brightly lit by streetlights, any traffic flowing past tends to get lost in the lights. Thomas shot three images: one of the sky with a red sunset, the buildings, and then the highway, which was a 20-second exposure at f22.

## enhance

Using the Magic Wand, the area above the road was selected and then erased. The highway was then selected and copied to a new document (1).

The skyline was then selected, copied and pasted to the composite document (2).

The two layers were overlaid and the Eraser tool used to remove unnecessary elements. Small segments from each image were selected and pasted into place as new layers (3).

The buildings were then selected with the Pen tool and copied to the composite image. As there weren't enough of them, some were copied and pasted in to fill out the skyline (4).

To get a greater sense of the towering city, individual buildings were selected and then stretched upwards (5).

**3 layers**

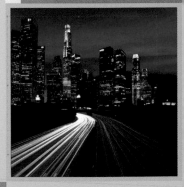

**4 paste**

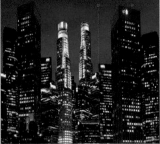

> digital capture
> magic wand
> copy and paste
> eraser
> pen tool
> 16-bit colour
> hue/saturation
> levels

**5 paste**

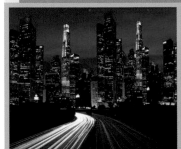

**6 paste**

At this point the image was converted to 16-bit colour so that at the next step, there was little increase in noise. The colour saturation was then increased and Levels used to add a slight contrast. Final tidying up was done, then the levels were merged (6).

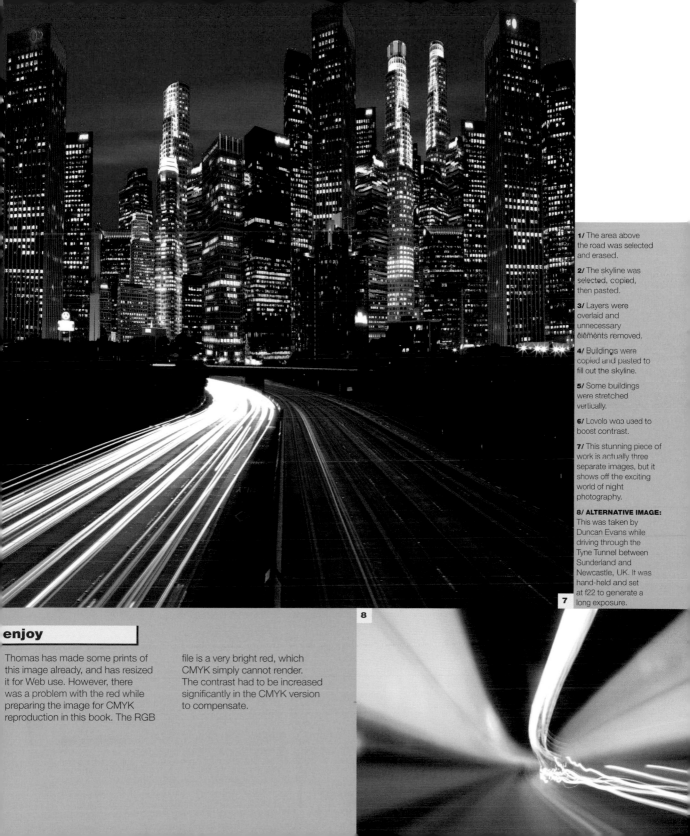

**1/** The area above the road was selected and erased.

**2/** The skyline was selected, copied, then pasted.

**3/** Layers were overlaid and unnecessary elements removed.

**4/** Buildings were copied and pasted to fill out the skyline.

**5/** Some buildings were stretched vertically.

**6/** Levels was used to boost contrast.

**7/** This stunning piece of work is actually three separate images, but it shows off the exciting world of night photography.

**8/ ALTERNATIVE IMAGE:** This was taken by Duncan Evans while driving through the Tyne Tunnel between Sunderland and Newcastle, UK. It was hand-held and set at f22 to generate a long exposure.

## enjoy

Thomas has made some prints of this image already, and has resized it for Web use. However, there was a problem with the red while preparing the image for CMYK reproduction in this book. The RGB file is a very bright red, which CMYK simply cannot render. The contrast had to be increased significantly in the CMYK version to compensate.

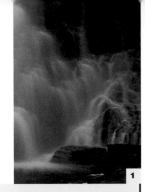

1

# waterfalls

Low light levels enable you to turn a waterfall into the rushing torrent that you can see here, into a magical curtain of misty spray. Due to the low light levels, exposure time is longer, allowing more water to rush past the camera. This results in the water blurring, but the background rocks and vegetation remaining sharp.

## shoot

Keith Saint of Ashington, England, shot this image of Hareshaw Linn, a waterfall in Northumberland, using a Canon professional SLR with a 70–200mm telephoto lens. It was shot at the 70mm end with an aperture of f11, giving an exposure time of 2.5 seconds.

2 **levels**

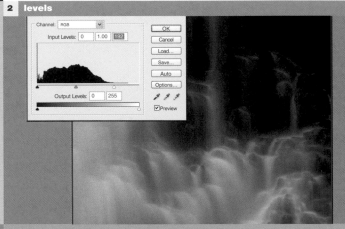

3 **curves**

## enhance

The Levels function was used to develop the full range of tones in the image. The mid-point slide was moved as well to brighten the image (2).

Curves was then used to darken the shadow areas a little and brighten the plumes of water (3).

The waterfall was a little cold from a slight colour cast so Colour Balance was used to warm it up by increasing the red and yellow elements (4).

4 **colour balance**

> digital capture
> levels
> curves
> colour balance

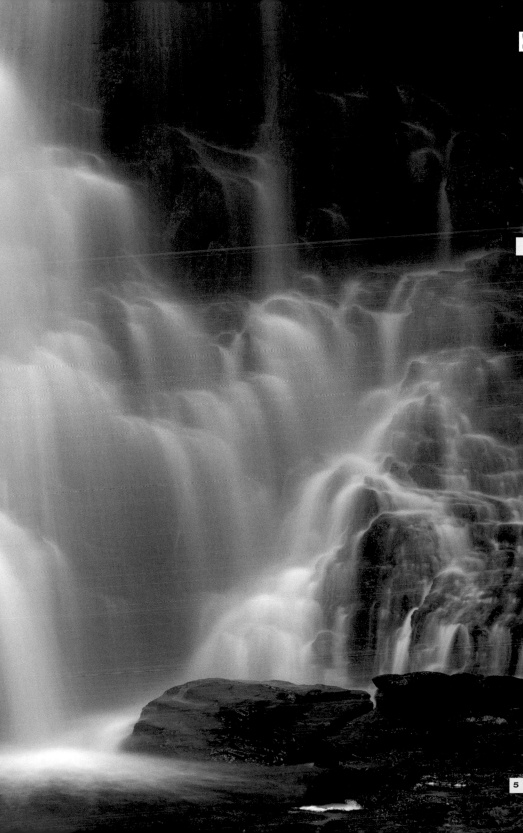

**!** The best time to shoot waterfalls is at dawn or dusk; light levels are low and the light in the sky can be dramatic.

## enjoy

Keith uses the Adobe RGB colour profile for a wider colour gamut and makes prints for himself and for competitions. He also hopes to put on an exhibition of his work. Images for display on his website are resized smaller and saved as JPEGs using the Photoshop Save for Web option.

**1/** The original image of this cascading waterfall is flat and lacks contrast.

**2/** Levels was used to get the full range of tones.

**3/** Curves was applied to brighten or darken selected areas.

**4/** The Colour Balance function was used to warm the image.

**5/** Now that the image has been brightened up and the blue colour cast adjusted, a perfect slow-motion waterfall picture is the result.

5

1

# shadowy figures

One of the most effective scenes to capture in a low-light situation is one where the landscape and architecture form an interesting picture, but people are present in it. The long exposure will render movements as a shadowy blur – influenced by speed and the proximity of any light sources. This adds a human, but otherworldly touch to the photo.

**1/** The original image shows the value in planning a shot and experimenting with exposure before shooting the scene with people in it.

**2/** Levels was used to adjust contrast.

**3/** Details were brought out using Unsharp Mask.

**4/** The image is given a human component by the blurred figures walking down the street.

> **digital capture**
> **RAW conversion**
> **levels**
> **unsharp mask**

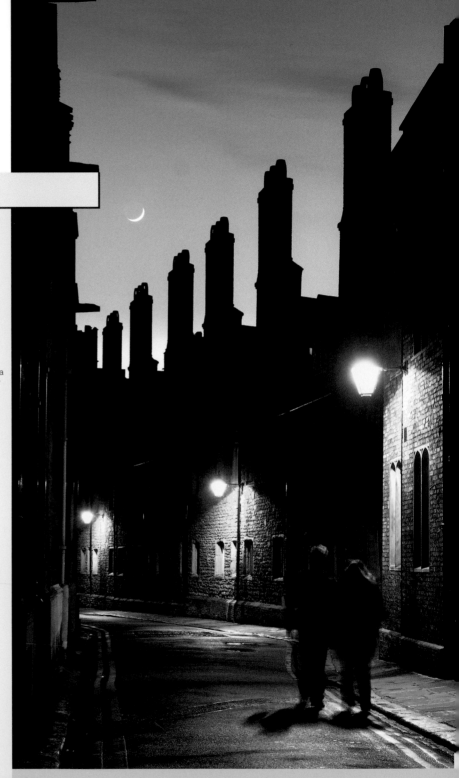

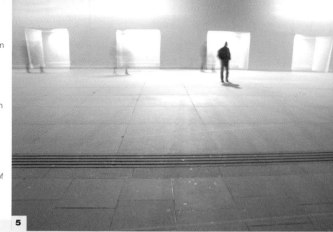

! Check how long the exposure is going to be before including people in the shot. Fire the shutter at the start of the scene as they walk through it.

**5/ ALTERNATIVE IMAGE:** This was taken near Trafalgar Square in London, at 7pm in the evening, by Paolo Corradini of Italy. A scaffold had been put up due to construction work. A man stopped for a few seconds so Paolo took the shot. What he likes most is the blurred profile. It was shot hand-held with a shutter speed of 1/4th of a sec.

**2    levels**

**5**

## shoot

This image by Sean McHugh is of Trinity Lane near the old city centre of Cambridge, England. Trinity Lane is one of the few thoroughfares established in Cambridge that leads towards the river. In the fourteenth century, it was lined with local shops owned by Michaelhouse. However, this empty lane is now frequented by students passing between the colleges. Sean particularly wanted to show this scene not long after sunset, when the endless line of chimneys created silhouettes against the sky. Warm, evenly spaced street lamps added enough light to create a shadowy blur of the couple under a cool sky and crescent moon. Sean shot the image with a Canon digital SLR using a Canon EOS 17–40mm f4 lens. He waited until the couple were in the right place before firing the shutter.

**3    unsharp mask**

## enhance

! If the exposure is so long that the people only register dimly, then increase the ISO or drop the aperture down to generate a faster shutter speed.

The image required little post processing because it was almost perfect. It was converted from a RAW image original then Levels was used to adjust the contrast (2).

Next, the Unsharp Mask filter was used to bring out the detail in the buildings and skyline (3).

! If the scene is unlit, people will hardly register at all. Look for a scene where there is an additional light source as this will provide enough illumination to highlight people subjects.

## enjoy

After this image was developed from the original RAW file, it was converted to sRGB because it did not contain extreme colours, which would be outside the gamut of this space.

This way, Sean could allocate the most bits to the medium colour tones. Although all of his images are partly for his own enjoyment, this image tends to be more commercial than most.

Preparation for Web use involved resizing to an appropriate, lower resolution, and then subtle sharpening was used to offset any softening caused by downsizing.

Wilson Tsoi of Mukilteo, Washington, USA, shot this picture of a tulip field on a very windy day using his Canon compact digital camera. The wind was blowing the tulips around, but because the light was so bright at midday, he was able to generate maximum depth of field and freeze the tulips in place.

**1/** Thanks to the very bright light, Wilson Tsoi was able to freeze the action on a very windy day.

**2/** Layers was used to adjust the horizon.

**3/** Curves gave the image more punch.

**4/** The Gaussian Blur filter was run on a duplicate layer.

**5/** The image was cropped to a square format.

**6/** The final image is crisp and colourful yet retains a painterly quality.

# windy conditions

There are two ways of photographing movement caused by the wind, depending on the lighting conditions. In a low-light situation, place the camera on a tripod – whatever is blowing in the wind will be recorded as a blur, while the surroundings will remain sharp. However, on a very bright day, there is enough light to shoot with the narrowest aperture and still freeze the moving elements.

## 2  new layer

## enhance

First, the clouds were selected with the Polygonal Lasso tool, then copied and pasted as a new layer. This layer was moved down so that they were closer to the horizon, then the layers were merged (2).

The contrast was adjusted with the Curves function to give the image more punch. The saturation was also increased slightly (3).

A duplicate layer was created and the Gaussian Blur filter used. The Opacity of the layer was reduced to 50%.

## 5  crop

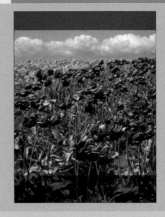

## 3  curves

## 4  gaussian blur

The Eraser was then used to delete the clouds and the ground under the red tulips. The idea was to give the tulips a more painterly feel (4).

Finally, the image was cropped to a square format (5).

> polygonal lasso
> copy and paste as new layer
> curves
> hue/saturation
> duplicate layer
> gaussian blur
> eraser
> crop

## enjoy

Wilson uses sRGB as the colour space when speed is required or the work is for normal processing. However, when critical work with heavy manipulation, press reproduction or a big enlargement is required, he converts the profile to Adobe RGB for the wider colour gamut. Wilson occasionally makes prints for his own enjoyment, but resizes to a smaller file size for posting on his Web-based portfolio.

On windy days with low light conditions, set your camera on a tripod and use the highest f-stop to obtain the longest shutter speed possible.

If the shutter speed still isn't long enough to blur objects moving in the wind, use a neutral density filter to further reduce the light levels.

If you want to freeze the action of the blowing wind, you need a fast shutter speed. Reduce the aperture down to f8 to get more speed, yet still retain a reasonable depth of field.

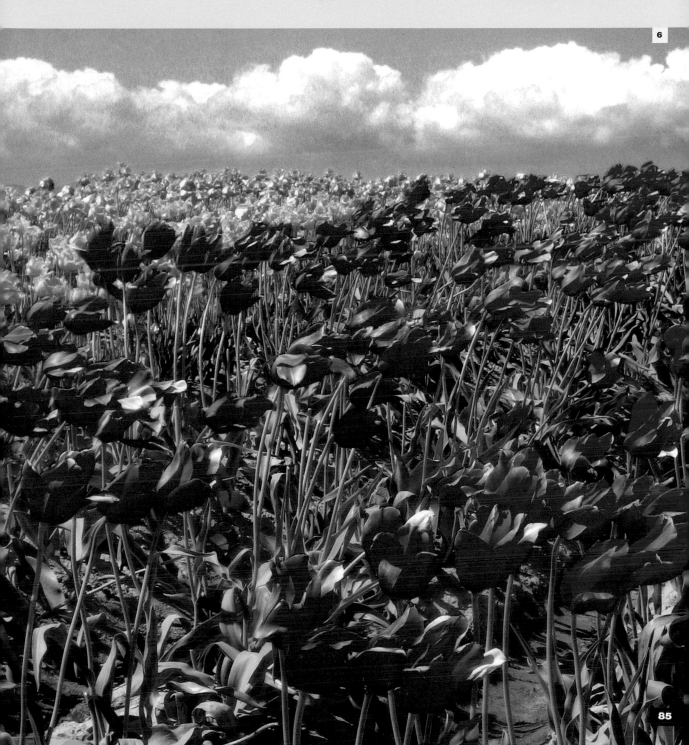

6

# 7  people in contrast

Bright or harsh light can be detrimental to portrait photography. Who wants pictures of people squinting in the sun? However, if you take the people and use them as graphic objects, then silhouettes, shapes and backlit portraits all become available. All you need to do is work the situation, take advantage of the conditions and get into the right position to make a successful photograph.

Kelly Munce, a native of Muswellbrook, New South Wales, Australia took this photograph of two of her daughters and a friend with a Kodak compact digital camera after sunset.

Kelly says, 'This shot was taken on a trip to Lake Liddell, Muswellbrook New South Wales. After taking these images we decided to incorporate them into a series entitled *My Favourite Years*. I find the best way to capture the moment is to just shoot everything that takes your eye.'

**photographers**

Kelly Munce
Wilson Tsoi
Nina Andersen
Jon Bower
Felipe Rodriguez

! To turn the person in the foreground into a black outline or shadowy shape, simply meter the bright sky. Even on zone metering, if you focus on the sky, the subject will usually be rendered dark or black.

! Backlit images can produce excellent and very graphic silhouettes of the subject. Look for a dramatic sunset or vivid sky and get your subject to move freely against it while snapping away.

# backlit subjects

Your camera, no matter what type or cost, can only capture a certain range of tones. When your scene has a wider range, there is a tendency for everything to get clipped off at the top or bottom end of the scale. The loss of white or black tones depends on the scene, the light sources and how you meter the exposure. The most typical example of this is bright sky and sunset. By capturing the brightness of the sky, anyone standing in the foreground is invariably rendered in shadow.

## shoot

It was a beautiful afternoon in early summer when Wilson Tsoi of Washington, USA, decided to do some fishing with his daughter. They went to Picnic Point beach in Edmonds, south of Mukilteo. Wilson followed his daughter around with a Canon compact digital camera as she searched for potential catch with her fishing net. He wanted to capture an image that showcased the beautiful time of day, the flavour of their locality, and most importantly, his daughter's enthusiasm for life. Wilson caught this spectacular image by staying low to render Rikki larger than her surroundings, while capturing the water's splashes and the cloud formations.

**2 hue/saturation**

## enhance

The colour was a little flat so the first stage was to increase it with Hue/Saturation. The saturation was increased by 15% (2).

As the colour of the sky rendered by the camera was slightly yellow-green, Colour Balance was used to change the hue to purple. The cyan-red slider was moved towards red and the magenta-green slider moved towards magenta (3).

Finally, the Curves function was used to darken the shadows and make the clouds stand out a little more (4).

**1/** With the camera on automatic setting, the metering automatically calculates the exposure for the sky, rendering the figure in shadow.

**2/** Saturation was increased by 15%.

**3/** Colour Balance was used to alter the hues.

**4/** Curves was used to darken shadows and enhance clouds.

**5/** The final image has been tweaked and the colour adjusted so that it fully depicts the stunning sunset.

**3 colour balance**

! To avoid capturing the subject as a dark figure you need to lighten up conditions either by using a reflector or flash.

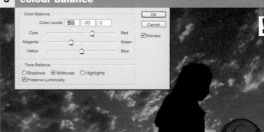

> digital capture
> hue/saturation
> colour balance
> curves
> resize for web

**5**

**4** curves

Channel: RGB

OK
Reset
Load...
Save...
Smooth
Auto
Options...

Input: 67
Output: 58

☑ Preview

Wilson occasionally makes prints for his own enjoyment. He posted this particular image to his Web-based portfolio by resizing smaller in Adobe Photoshop and saving it as a JPEG. He uses sRGB colour profile for convenience and speed. However, if a project requires extensive manipulation he converts an image to Adobe RGB for greater colour gamut.

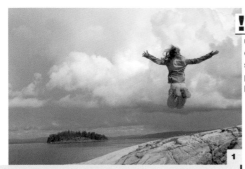

! Bright light during the middle of the day will cast ugly shadows on the face, or cause the subject to squint. Get around this by photographing subjects from behind in an abstract fashion.

! To avoid the ugly effects of bright light, why not get the subject to wear a hat to shade their eyes from the glare and fill-in with flash?

! Shooting someone against a white background produce a high key image. Simply spot meter from the subject's face.

1

# high key images

A high key image is one where the majority of the tones are in the lighter end of the spectrum. High key images are very popular in lifestyle photography, but are also an ideal solution to shooting during the middle of the day, when the lighting is generally poor. They can vary from simply being quite light, to having a completely white background, with most detail – apart from the subject – bleached out.

## shoot

Nina Andersen took this picture at Høvik Vollen, by the Oslo Fjord in Norway. It was early summer and the sky was bright and glaring, despite the cloud cover. The conditions were unsuitable for shooting traditional portraits. Nina was there to capture images of her daughter jumping to illustrate joy and freedom. A girl nearby asked if she could be in a picture as well. This image, taken on a Canon professional digital SLR using a Canon EF 24–70mm f2.8 lens, was one of Nina's favourites from the session. It looks like the girl is trying to reach for the sky.

2  crop

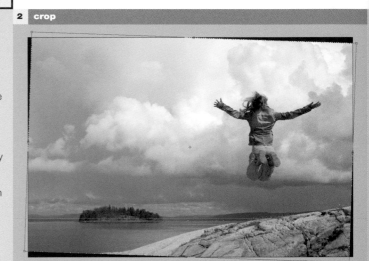

> digital capture
> select
> transform
> rotate
> crop
> dodge
> burn
> gradient map
> curves adjustment layer
> hue/saturation adjustment layer
> merge all
> save as TIFF

3  dodge and burn

## enhance

First, the image was rotated and the Transform> Rotate option used to get the horizon straight. Then, it was cropped to remove unnecessary elements (2).

Next, the Dodge and Burn tools were used to lighten areas on the sea and darken the clouds (3).

The foreground colour was then set to black, the background colour to white and a Gradient map adjustment layer added to convert it to a black-and-white picture (4).

A new Curves adjustment layer was created and a slight S-curve used to add more contrast. In the Histogram, you'll see the majority of

4  gradient map

the tones to the right are in the lighter spectrum, making this a subtle high key image (5).

A Hue/Saturation adjustment layer was added to create a brownish sepia tone. The Colourize option was ticked to add the colour. The layers were merged and the image saved as a TIFF (6).

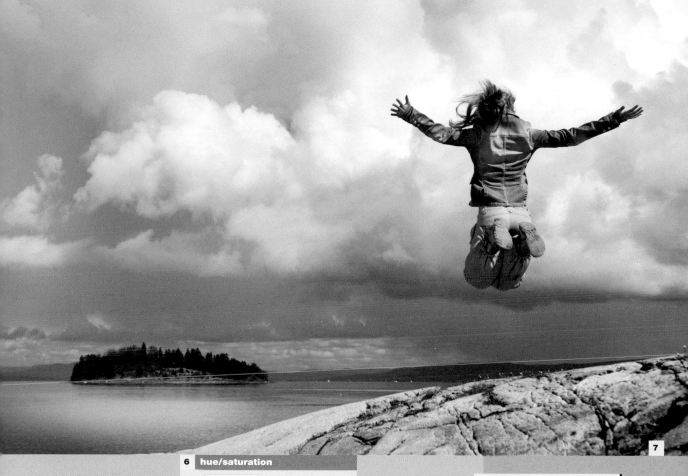

## 6 hue/saturation

Edit: Master

Hue: 34

Saturation: 14

Lightness: 0

OK
Cancel
Load...
Save...

☑ Colorize
☑ Preview

## 5 curves

Channel: RGB

Input: 187
Output: 191

OK
Cancel
Load...
Save...
Smooth
Auto
Options...

☑ Preview

7

**1/** The original image makes use of the bright light by generating a fast shutter speed to freeze the jump.

**2/** The image was rotated then cropped.

**3/** Dodge and Burn tools were used to brighten the image.

**4/** A Gradient Map adjustment layer was added.

**5/** Curves was used to add contrast.

**6/** A brownish, sepia tone was added using Hue/Saturation.

**7/** The final image maximises the potential of the lighting conditions, while skillfully avoiding the drawbacks.

## enjoy

Up until now Nina has just taken photographs for her own enjoyment, but recently she has been lucky to be signed to Norway's largest stock agency, Scanpix. The colour version of this picture is now in their database, and Nina hopes to make some sales from it. To prepare it for Web use it was resized in Photoshop, sharpened, and the colour space converted to sRGB.

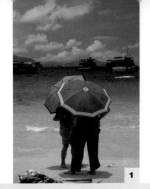

# the midday sun

The sun's bright, midday light is poor for portraiture because the subjects end up squinting and ugly shadows are cast everywhere. There are ways to circumvent the problem, such as placing the subjects in shadow, but then you'll need fill-in flash to brighten them up. A clever alternative is simply to place the subjects as graphic objects within the scene, so that the picture is not about detail.

## shoot

Jon Bower was living and working in Hong Kong when he was invited by his boss on a trip to the Sai Kung Peninsula and its exclusive beaches. In reality, the place was crawling with boats and tourists, including these two old ladies sheltering under an umbrella. He shot the image and then forgot about it until he became proficient in Photoshop.

## 3 curves

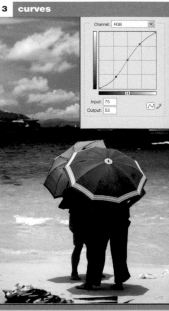

## 2 levels

## enhance

The first stage was to stretch out the Levels to boost contrast (2).

The Curves option was then used to fully enhance the shadows and brighten the highlights by using a typical S-shaped curve (3).

## 4 hue/saturation

The Hue/Saturation control was used, with specific selection of blues and greens to enhance the colour of the image. The Colour Balance was also used to make the colours richer and remove the blue cast (4).

The Clone Stamp and Healing brushes were then used extensively to remove all the boats on the horizon, along with the pieces of wood just in front of the subjects' feet (5).

## 5 clone tool

> film capture
> hi-res scan
> levels
> curves
> hue/saturation
> colour balance
> clone stamp
> healing brush

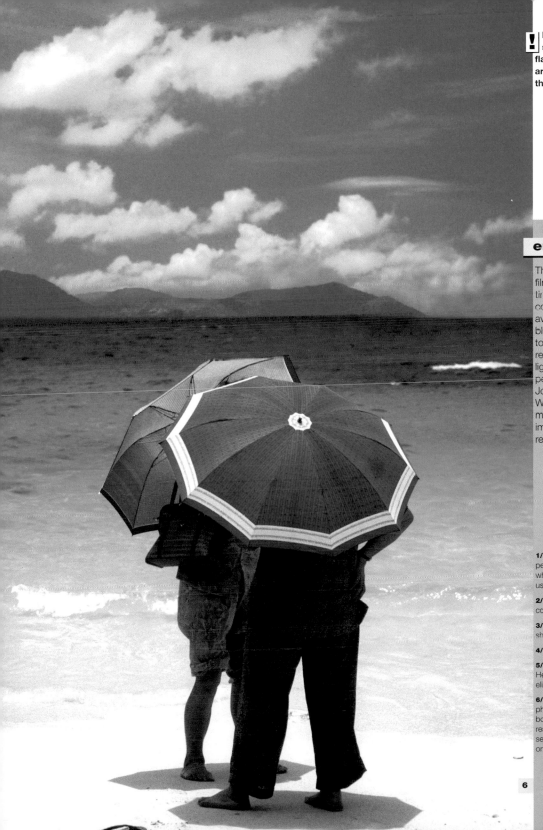

! If shooting faces in shadows, use fill-in flash so that subjects are as bright as the background.

## enjoy

This photograph was shot on film 20 years ago and with time had acquired a blue colour cast to go with the awful tropical lighting and bleached colour. Jon decided to remove the objects and restore the colour and lighting digitally. This was a personal project; most of Jon's commercial work is Web-based. He intends to make a large print of the image to see how good the repair work has been.

**1/** The original image was full of people and boats, the latter of which Jon decided to remove using Photoshop.

**2/** Levels was stretched to obtain contrast.

**3/** Curves was used to enhance shadows and brighten highlights.

**4/** The blue cast was removed.

**5/** The Clone Stamp tool and Healing brushes were used to eliminate clutter.

**6/** The final image is a triumph of photo editing; Jon has removed boats and unnecessary clutter, restoring the exposure and colour seen when the photograph was originally taken.

6

# silhouettes

One outcome of shooting very bright backgrounds is that any figures in the scene will appear as silhouettes. Spot metering from the subject, however, will turn the background white. The objective is to capture an interesting shape for the silhouette because all you have to work with is the outline. The background should then provide the rest of the interest in the photo.

## shoot

This photograph was taken by Felipe Rodriguez of Spain from his own balcony in Seville city centre. The street faces southwards, so it is always bright and shiny at noon.

Felipe has learned that by metering on the cobblestones, you get a dark silhouette and shadow from backlit subjects, along with a nice texture on the cobblestones. Hence, he simply

waited with his camera until an interesting subject came along and then shot her with his Fuji digital SLR and a powerful Nikkor 80–400mm VR telephoto lens.

## enhance

The exposure was a little flat, so the only real post-production editing was to use Curves and an S-shaped curve to make the highlights brighter and the cracks in the stones sharper (2).

As the image contained very little colour anyway, Felipe changed the image mode to Greyscale, discarding the colour information and making it easier to print out in black and white (3).

## enjoy

Felipe prints pictures for his own enjoyment and also for exhibition. For Web use he resized the image to 600 x 400 pixels and then applied some sharpening with the USM filter.

For colour pictures for Web use, he changes the colour profile to sRGB and boosts the saturation to compensate for the narrower colour gamut.

> digital capture
> curves
> greyscale
> resize for web
> unsharp mask

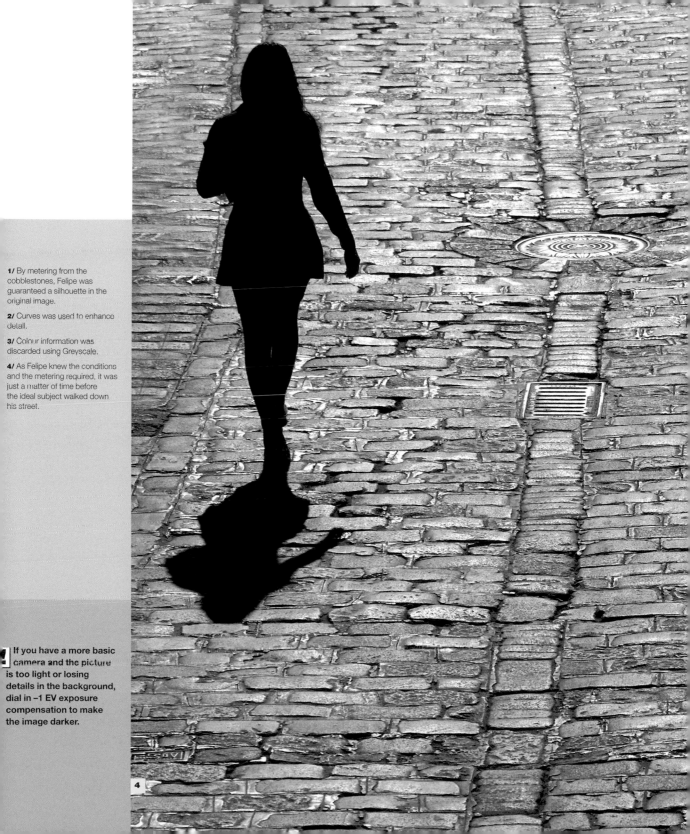

**1/** By metering from the cobblestones, Felipe was guaranteed a silhouette in the original image.

**2/** Curves was used to enhance detail.

**3/** Colour information was discarded using Greyscale.

**4/** As Felipe knew the conditions and the metering required, it was just a matter of time before the ideal subject walked down his street.

If you have a more basic camera and the picture is too light or losing details in the background, dial in −1 EV exposure compensation to make the image darker.

> Despite the lack of good light, try to get a good depth of field so that all the objects are sharp. It will make processing the image easier on the computer as there won't be elements out of focus from using a wide aperture.

> Sometimes, images like these only suggest themselves when you are looking at the picture on the screen. However, when the weather is bad and you are facing a washout, look for the strong forms in the landscape to produce a graphic image later.

**2  greyscale**

# graphic images

There are times when the conditions are extremely bright or reflective that the resulting picture doesn't work. Digital editing can take the image one step further to produce a graphic, almost two-tone image. The key to this kind of image is simplicity, as too much detail will degenerate into a mess when it is reduced to the graphic elements.

## shoot

Jon Bower was in a shellfish restaurant in Dalian, a coastal port in the far north east of China. It was a cold winter's day – cloudy and drizzly. While dining, Jon spotted fishermen off-shore and recognised that despite the appalling grey light, some strong visual forms were presenting themselves.
He took some long shots with his 65–200mm lens.

## enhance

The main effort was in extracting and abstracting the very strong forms apparent in an otherwise flat image. Firstly, the mode was changed from RGB to Greyscale, which discards all the colour information (2).

The image was then cropped to get rid of the boat nearest the camera. The object was to achieve simplicity, which meant including just the two boats (3).

The boat was selected, feathered and then cut and pasted into a new position, covering the top of the figure remaining at the bottom of the screen (4).

The gap left behind was cloned over quite roughly. Subtlety was not required because brightening was going to be introduced in subsequent steps.

The Curves function was used with a very radically shaped S-curve. This

**3  crop**

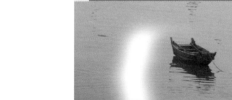

gave the graphic image effect at the top of the picture (5).

A Curves adjustment layer was then used to turn the bottom image into a graphic image. This lost the power lines at the top so a gradient was used on the mask for the top part of the image. Final Levels adjustments and some cleaning up work completed the image (6).

**4  cut and paste**

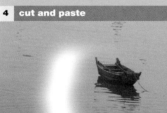

> film capture

> scan

> greyscale

> crop

> selection

> cut and paste

> clone stamp

> curves

> curves adjustment layer

> gradient mask

> levels

> minor cleaning

**5  curves**

Channel: Gray

OK
Reset
Load...
Save...
Smooth
Auto
Options...

Input : 61 %
Output : 90 %

☑ Preview

**1/** In conditions of high reflectivity, Jon Bower interrupted his lunch to take some long-distance shots.

**2/** The mode was changed from RGB to Greyscale.

**3/** The image was cropped.

**4/** A boat was cut and pasted to a new position.

**5/** Curves was used to graphic effect.

**6/** Levels adjustments were done to finish the image.

**7/** With layer effects, Curves and Gradient masks, Jon has transformed the dull picture into a graphic, stylised image.

## enjoy

Jon works exclusively in Adobe RGB for post-processing because it offers a good colour gamut. It is also an industry standard and Jon finds sRGB too limiting for scanned film. He makes prints primarily for his own use or exhibition. His commercial work is almost exclusively Web-based.

**Bad weather and poor lighting pose problems for colour photography, but keep shooting anyway, because they make fine subjects for black-and-white photography.**

**6  curves mask**

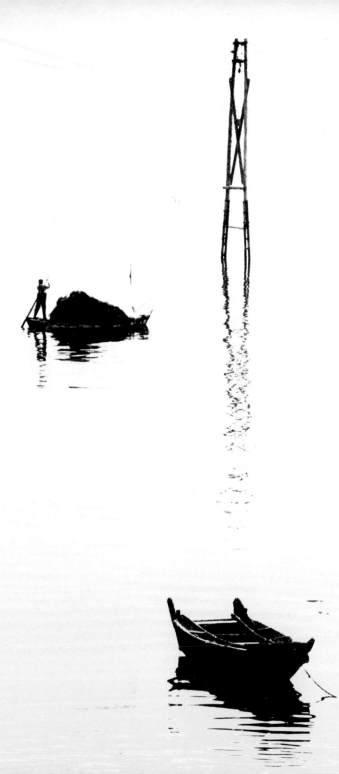

7

# 8  painting with light

This is a technique that takes place in a darkened room or location where the subject is illuminated with a torch or other light source. The exposure should be long enough so that the "painting" can take place. The results are often magical as it is an artistic process requiring the photographer to build light up like layers of paint.

Marion Luijten shot this image of flowers using a Canon digital SLR with a Sigma 105mm lens. The exposure was 11 seconds – allowing her just enough time to paint the flowers.

Marion says, 'Because my objects [the flowers] were very small, I used a mini Maglite instead of a large torch or bulb. It took lots of shots and settings to get the light right. It's a matter of trying and trying again as you have no way of metering the light beforehand.'

**photographers**

Marion Luijten
Roger Tan
Eric Kellerman
Dirck DuFlon

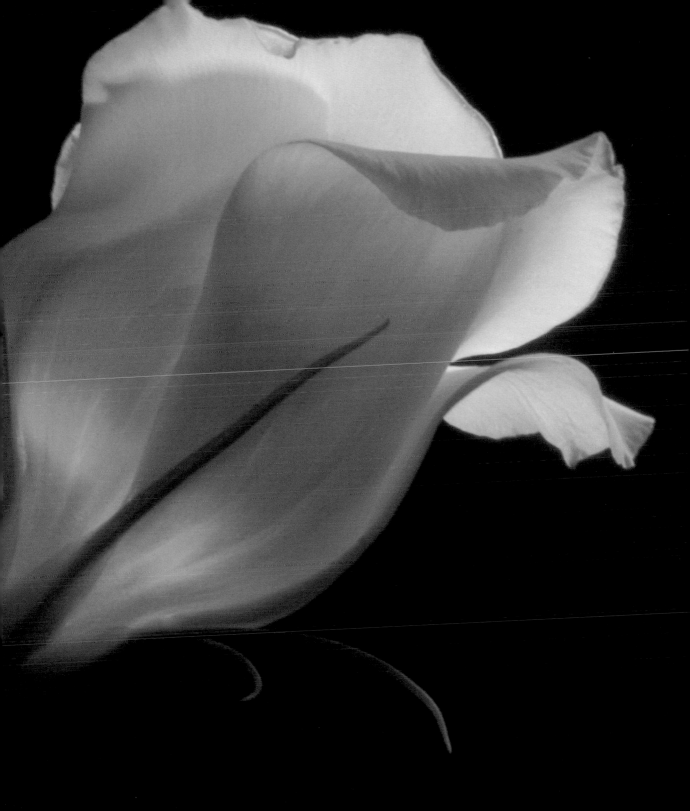

! Remember to set the shutter speed to a long enough exposure to give you time to paint all of the object.

! When painting with light, the narrower the aperture, the less background light you will pick up. Keep in mind that shooting at night will help reduce the ambient light to zero.

# painted flowers

One of the attractions of painting still life or flowers with light is the ability to set up in daylight with the camera mounted and properly focused before you start. The curtains or backdrop can then be drawn and the painting begun. With flowers, the diffuse light works best on semi-opaque petals, giving the whole enterprise an aura that is impossible to create with standard lighting.

## shoot

There is a story as to why Roger Tan of Guangzhou, China, shot this flower. While living in Melbourne, Australia, his nearest neighbour was a charismatic lady called Mrs Myra Wilson. Myra loved her garden and every spring Roger enjoyed watching her prune the Magnolia tree and its beautiful blossoms. Roger returned to Australia in 2002 to find that, sadly, Myra had passed away. When spring came again Roger revisited Myra's Magnolia tree. He pruned some of the hanging branches and placed them in a vase next to his bed. He decided to create a permanent reminder of Myra's Magnolia.

For this shot, Roger used a high-end Sony digital compact. He chose the flower in question because the branches resembled fingers, cupping the flower. He organised the camera and composition then set up the background by draping a black jumper over the backrest of a chair. Next, he set a dim halogen lamp below to define the branches, and turned off the room lights. The image was taken at night.

When the shutter was released, Roger switched on his hand-held torch and played the beam over the flower from the top, with small circular motions, moving left to right. He then switched

to the front and painted light on to each petal, the leaves and then the branches, using faster strokes. He used an aperture of f8 (the maximum on the Sony camera) to get as much depth of field as possible and to enable a longer capture time. This took four seconds, which required some nifty torch work from Roger.

! The exact settings required are best arrived at through trial and error as every torch will give a different volume of light. Start by setting the aperture to f8 and the shutter speed to eight seconds; paint away and assess the picture afterwards. If areas are burnt out, increase the aperture and reduce the shutter speed or the amount of light painting that you do.

> digital capture
> clone stamp
> CMYK conversion
> contrast adjustment
> interpolation
> save for web

**2  clone tool**

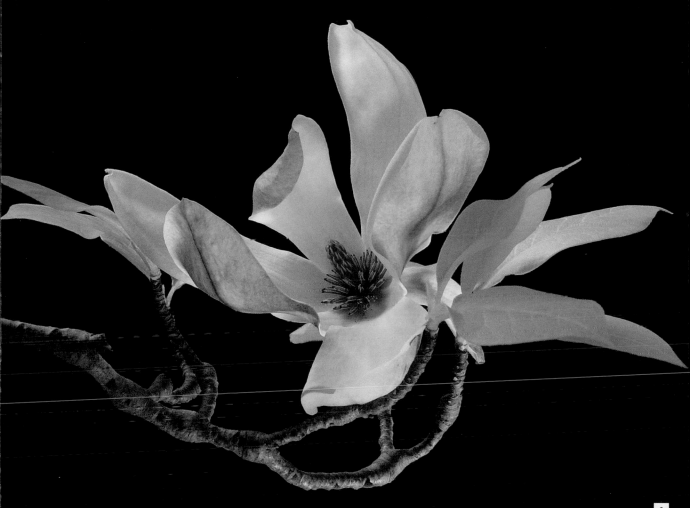

## enhance

The only real manipulation was to use the Clone Stamp tool to remove spots of light in the background (2).

The image was converted to CMYK for use in this book, which lost some of the image's colour and impact. The contrast was subsequently given a slight adjustment to make it closer to the RGB image (3). It was also slightly interpolated to allow for larger printing.

**3 brightness/contrast**

| Brightness: | 0 | OK |
| Contrast: | +4 | Cancel |
| | | ☑ Preview |

**1/** The original flower shot is very close to the finished product as it is relatively unprocessed.

**2/** The Clone tool was used to remove spots of light.

**3/** Brightness and Contrast was adjusted.

**4/** For use in this book we converted the image to CMYK, which required a little tweaking to restore it to its full glory.

## enjoy

Roger makes prints for his own enjoyment and also for exhibition. This picture was chosen for the booklet of a CD by a music publisher in China. A print of this image has also been presented to Myra Wilson's son as a souvenir to remember his mother's Magnolia. Roger prepares his images for display on the Web by using Photoshop's Save for Web feature.

**3  clone stamp**

# soft and dreamy nudes

One alternative to using a torch to paint with light is a low-power household bulb. The spread of light is greater, giving a softer result and reducing the incidence of bright spots. You can use household lamps or a bulb on a flex lead, but the important point to remember is that the bulb should be shielded from the camera, to avoid bright streaks of light.

## shoot

Eric Kellerman, a native of Berg en Dal in the Netherlands, shot this image in the studio of an art college in Denmark. He used a Nikon digital SLR and a 28–70mm f.28 telephoto lens. The aperture setting was f14 to allow for an exposure time of 40 seconds. This ensured that there would be no background ambient light and allowed enough time to paint. A domestic light bulb of low wattage (40 watts) was placed in a lamp holder on a long lead and used to illuminate the subject wherever it was required. The bulb was shielded from the camera by a lampshade made of stiff, black paper, keeping the stray light out of the lens. The camera was set in Bulb mode and placed on a tripod.

**2  crop**

**4  curves**

Channel: RGB

OK
Cancel
Load...
Save...
Smooth
Auto
Options...

Input : 67
Output : 57

☑ Preview

## enhance

The image was cropped to a square format to get rid of the empty space on the left (2).

The Clone Stamp tool was used to remove the light flaws caused by shining the bulb directly at the camera lens. It was also used to remove skin imperfections, dust spots and the odd hot pixel that resulted from the long exposure (3).

The photograph was then toned with a plug-in called Power Retouche and the highlights and shadows were given a final adjustment with Curves (4).

The Unsharp Mask filter was used to enhance the grainy aspect of the image and bring out the textures (5).

**1/** As with all painterly exercises, the results are not entirely predictable. Here, the lamp has been exposed to the camera, resulting in visual flaws.

**2/** The image was cropped to a square format.

**3/** The Clone Stamp tool was used to eliminate light flaws.

**4/** Highlights and shadows were adjusted using Curves.

**5/** Unsharp mask was used to enhance the grainy aspects of the image.

**6/** After cleaning and toning, the image now presents a beautifully soft and artistic nude form that would be difficult to create using standard flash.

**5  unsharp mask**

OK
Reset
☑ Preview

⊟  25%  ⊕

Amount: 50  %

Radius: 2.0  pixels

Threshold: 3  levels

> digital capture

> crop

> clone stamp

> Power Retouche plug-in

> curves

> unsharp mask

| Ensure that the aperture and shutter speed combination eliminates any ambient light in the room. Aim to give yourself at least 20 seconds to paint the subject with light.

| ! | Focus on the subject before turning off the main lights or blocking the windows. Turn off the auto-focus. In the dark, there will be no opportunity to focus on the subject.

## enjoy

Eric uses Adobe RGB because it provides the widest in-camera colour gamut, which he can then print out retaining all the tones. He uses an Epson printer with Hahnemuhle Photo Rag art paper.

Eric has had exhibitions in Denmark, the UK and the Netherlands. He is also represented in galleries in both the US and the Netherlands.

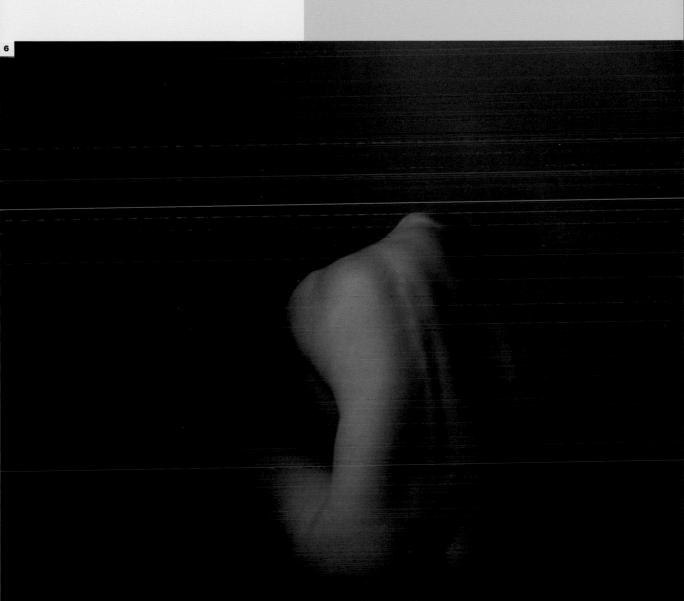

Brightness: 0

Contrast: 30

OK
Cancel
☑ Preview

**!** Try to keep the light moving to avoid developing hotspots on the image.

# the vintage look

Light painting offers a distinct advantage as it doesn't have the harsh qualities of tungsten or flash. If you match this technique with something that is either old or fading, you can readily produce a vintage look.

**2 levels**

Channel: RGB

Input Levels: 0 1.00 154

Output Levels: 0 255

OK
Cancel
Load…
Save…
Auto
Options…

☑ Preview

**!** To give an even older feel, try desaturating the image and then applying a sepia tone.

## shoot

This photo by Dirck DuFlon of Florida, USA, features two Southern Magnolia blossoms that he picked from a tree in his backyard. As they age and wilt, the creamy white of the petals turn brown, revealing beautiful rich tones that convey a vintage look. Dirck placed the blossoms on a bamboo mat and set his camera up in a completely dark room, along with a tripod and an electronic remote shutter release. He set the aperture to its widest setting (f3.5) and used a long exposure of 20 seconds to give him the time to softly illuminate the blossoms from all directions. He fired the shutter and while using a small flashlight filtered through tissue paper, he moved the light around to illuminate every surface and fold.

> digital capture
> levels
> brightness/contrast
> burn
> dodge

## enhance

The Levels option was used to brighten the image and also fill out some of the lighter tones. The image had a very narrow tonal range so the Levels command was used to spread these out (2).

The contrast was then significantly increased by using the Brightness/Contrast control (3).

The Dodge and Burn tools were used at 5% Opacity to lighten and darken certain areas of the image (4).

**4 dodge and burn**

## enjoy

Dirck has exhibited his images. He uses the sRGB colour profile, simply because that's the only option in his current camera. The aim in this picture was to bring out the highlights and patterns produced by the painting technique so that the print suggests a richer and older feel.

**1/** Underexposure is a common result of painting with light.

**2/** The image was brightened using Levels.

**3/** Contrast was increased.

**4/** Dodge and Burn tools were applied.

**5/** After some modification, the image now has rich colours and a vintage feel, thanks to the painting with light technique.

**!** Aside from wilting flowers, old books, vases, toys and traditional writing materials all make good subjects for this kind of shot.

5

# 9  the warmth of candlelight

The glow of candles lends an intimate, childlike, nostalgic and homely feel to images. The combination of little bright lights twinkling, shadows, a warm glow and colour casts can be evocative of Christmas, luxury, warmth and romance. Focusing and metering candlelit scenes can be difficult, but the results will be worth it.

The Candlelight Reader by Anupam Pal shows the Principal of a college in India, reading by candlelight.

Anupam says, 'I shot it using the candlelight as the only source of light to make a simple picture more interesting. By using the bright flame of the candle and a dark background, I tried to draw the viewer's attention directly to the action.'

**photographers**

Anupam Pal
Detlef Klahm
Judi Liosatos
Jean Schweitzer

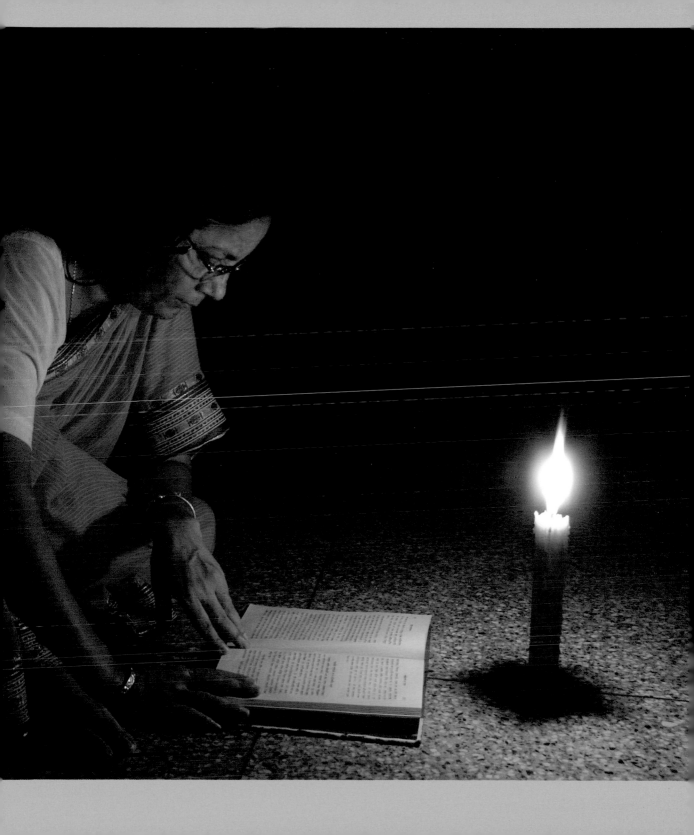

> ! Candles have a very low colour temperature. While a pleasant orange-red colour cast is one of the reasons for using candles in the first place, if the automatic white balance on your camera isn't very reliable, the skin tones can be rendered an unpleasant shade of red. Try alternative manual white balance settings as well.

1

# nudes

While there are many ways to successfully light a nude portrait, the use of candles adds an extra twist to the image, particularly if candles are the only light source. Getting a good balance of light or using it to highlight certain areas is the key.

## shoot

Detlef Klahm of Vancouver, Canada, decided to shoot a nude study in the studio and light it with just candles. The hardest challenge in making the image was placing the candles on the body so that it would look visually exciting. From a practical point of view, he had to be very careful where they were placed as movement from the model's breathing could have caused the candles to tip over. Detlef shot the image with a Nikon digital SLR and a 35–105mm Nikkor telephoto lens.

2  **selective colour options**

## enhance

The first step was to go to the Layers palette, click on New Adjustment Layer and select Selective Colour as the layer type. The reds were selected and the cyan component reduced to make the image warmer. The black was increased to make it moodier (2).

3  **hue/saturation**

1/ By carefully positioning the lights, Detlef Klahm managed an unusual studio nude by candlelight.

2/ Colours were adjusted to add warmth and mood.

3/ Saturation was increased.

4/ Features were sharpened using Unsharp Mask.

5/ Through the use of low light and candles, Detlef Klahm has constructed a warm image.

The saturation was then increased with the Hue/Saturation control to make it look warmer (3).

Finally, the Unsharp Mask filter was used to sharpen detail in the picture, bringing out skin texture and defining the outline (4).

> digital capture

> selective colour
   adjustment layer

> hue/saturation

> curves

> resize for web

> CMYK

> curves adjustment layer

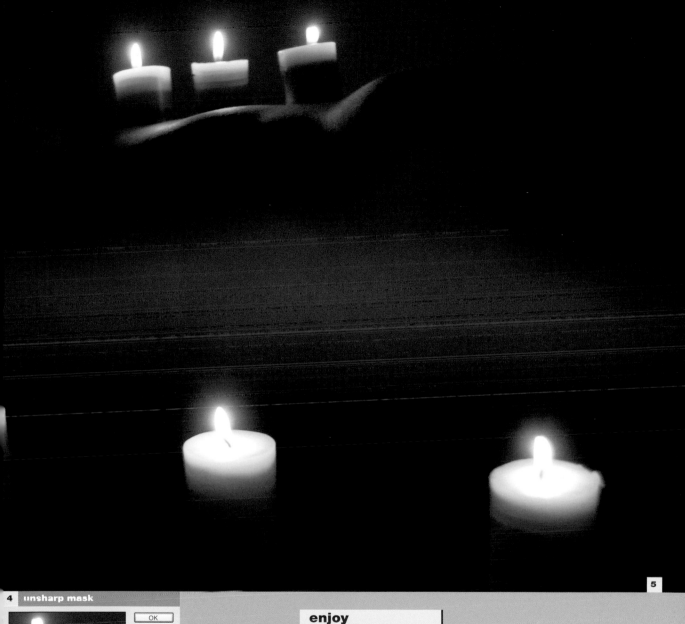

**4** **unsharp mask**

OK
Reset
☑ Preview

─ 50% ⊕

Amount: 100 %

Radius: 2.0 pixels

Threshold: 1 levels

**!** **From a practical point of view, make sure that the model isn't going to get burnt by the flame or splattered with hot wax.**

### enjoy

Detlef uses many of his images for competitions, local and national camera clubs, as well as photo-forums on the Internet. Sometimes they are also used for private sales or submission to magazines. He normally chooses a file size of under 100K and JPEG format for Web use only.

For conversion to CMYK there were significant clipping problems because of the warm colour, which required the file to be modified with a Curves adjustment layer.

! It's worth pre-focusing on the subject then turning auto focus off before dimming the lights and lighting the candle; auto focus isn't reliable in the dark.

**2  adjustment layer**

# telling a story

**3  mask layer**

There are some types of light that are designed to create an engaging narrative. Diffused window light is one and candlelight is another. As well as providing light, the candles become part of the story or scene – something that household bulbs and studio flash almost never do. Endeavour to use the light as part of the scene, as well as the primary source of illumination, for interesting, story-driven photographs.

## shoot

Judi Liosatos of Queensland, Australia, took this image at night. She didn't have a tripod to hand so had to increase the digital ISO to 200 to get an exposure time of 1/8th of a sec. The only light in the entire scene came from the candle. This was photographed on a Sony prosumer digital compact indoors to prevent the flame from flickering. Judi's daughter, Kita, had to hold her breath to prevent any movement from both herself and the candle. Since Judi was working with a young child, she had to make the shoot as quick as possible, so shot a lot of JPEGs instead of the time-consuming RAW format. This was a real disadvantage as the RAW format would have offered more control over the white balance in post-production.

## enhance

The low light and slightly high ISO produced more noise, so the image was processed through the Neat Image noise reduction filter.

The Clone Stamp tool was used to remove small pieces of hair near Kita's shoulder. A solid colour adjustment layer in black was created in the Layers palette and moved to the bottom of the layer stack (2).

A mask was added to Layer 0 and this was painted with black to remove the bottom and right side of the image (3).

A Curves adjustment layer was added to brighten the image without causing hot spots (4).

Another adjustment layer was added, this time using the Channel Mixer. This worked well on the majority of the image, but not the candle itself. The candle was subsequently masked out of this layer (5).

**4  curves**

> digital capture

> Neat Image noise reduction

> clone stamp

> solid colour layer

> curves layer

> channel mixer layer

> mask selection

> invert

> channel mixer layer

> solid colour layer

> save file

> PSP 9 filters

> crop

**5  channel mixer**

1/ The original image is noisy and has a significant colour cast.

2/ A solid colour adjustment layer was created.

3/ A mask layer was added to remove segments of the image.

4/ The image was brightened without causing hotspots using Curves.

5/ The Channel Mixer was used to add another layer.

6/ Another adjustment layer was added.

7/ A solid colour adjustment layer was added.

8/ After a marathon exercise in photo editing, Judy has restored the poor original and can now tell the story she was hoping for.

**6  channel mixer adjustment layer**

The mask was right-clicked and Set selection to Layer Mask chosen. The selection was then inverted. Another Channel Mixer adjustment layer was added (6).

To tone the image with the desired final colour, a solid colour adjustment layer was added. The image was saved at this point (7).

Judi then switched to Paint Shop Pro 9 to use the Enhance Photo filters. On this image she used Clarify, Edge Preserving Smooth and Sharpen.

The completed image was then cropped to remove wasted space around the edges.

**7 solid colour adjustment layer**

## enjoy

Judi sells her images commercially and also prints them for personal use. She usually reduces the image down to about 800 pixels on the longest side for the Web, but keeps all high resolution formats on file.

**!** When shooting very low-light scenes such as this, do not rely on automatic white balance. Set the white balance manually.

**!** The candle should fit in with the story that you are trying to convey. Shop around for candles that will help expand the narrative of the scene.

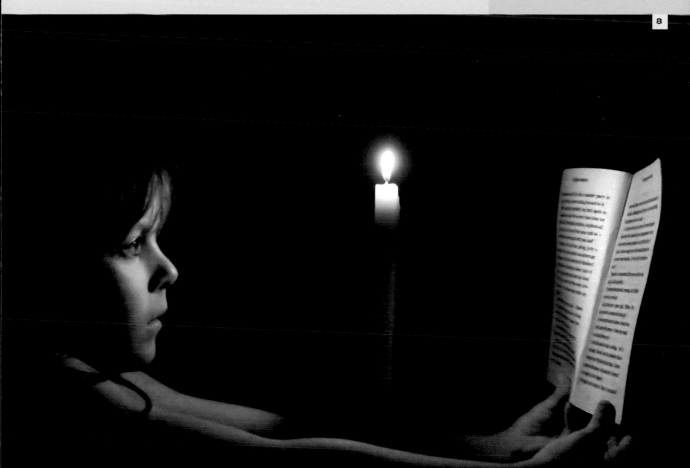

!  Children holding candles make for a great image but they need to be warned about the dangers of naked flames; check where the wax is going to run first.

**1**

# children by candlelight

One of the attractions of candlelight is that it is virtually the lighting opposite of studio flash, and as such heralds a more innocent time. This effect is specifically created when photographing children with candles – the image acquires a traditional and heart-warming aspect.

## shoot

A few days before Christmas, Jean Schweitzer decided to take a photograph of his two daughters holding candles, with a view to making a Christmas card using the result. He shot the image with a Canon digital SLR using a Canon 50mm f1.4 lens. Even though the light sources were mixed, he left the camera white balance on the auto setting. This ensured that there was a warm cast to the image.

**2  levels**

**4**

**1/** The image has a very shallow depth of field and some lens flare.

**2/** Levels was adjusted to add more contrast.

**3/** Lens flare artefacts were removed using the Clone Stamp tool.

**4/** Jean has produced a perfect shot for family Christmas cards.

**3  clone stamp**

## enhance

As this image was virtually perfect straight out of the camera it only required a couple of tweaks. Firstly, the mid-point carat of the Levels function was adjusted to put more contrast into the image (2).

Next, the Clone Stamp tool was used to remove lens flare artefacts caused by standing too close to the subjects. In some areas the brush mode was set to Darken, and in others to Normal, for the cloning work (3).

> digital capture
> levels
> clone stamp
> CMYK

!Light levels from candles are obviously very low and children find it hard to sit still – you will either need supplementary light or a lens with a very wide aperture of f1.4 or f1.8. Otherwise, the resulting low shutter speed will incur blur and camera shake.

!You can always mount the camera on a tripod for this kind of shot. Generally, if the subjects are still, you can shoot at exposures as long as half a second. However, they will need to be very still for an exposure of that length.

### enjoy

To be used in this book, the image lost a little colour and contrast to accommodate CMYK printing. Colour and contrast were increased to restore the overall look and feel. Jean also resized and posted a small JPEG version to his Webspace.

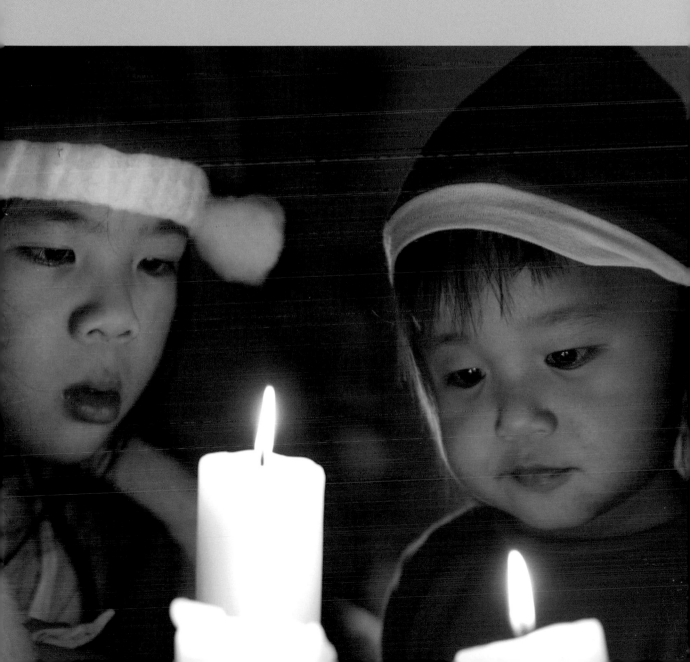

# 10  tungsten glow

The versatility of the humble tungsten lamp is surprisingly large, as it can be used as an additional light point in a landscape, a means of lighting a portrait, or illuminate a still life. The only disadvantage of using tungsten is that they have a very low colour temperature, which gives everything an orange-red colour cast. This can be eliminated by using white balance control or exploited to give an image a specific look and feel.

NY Mist by Deryk Baumgaertner of Cologne, Germany, was shot with a Canon digital SLR, using a number of filters to enhance the tungsten lamps throughout the scene.

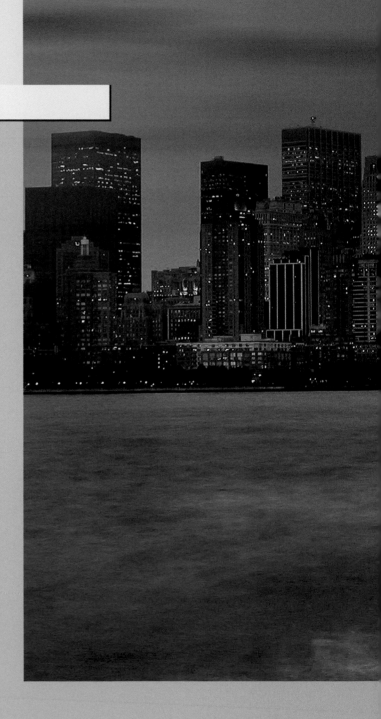

**photographers**

Deryk Baumgaertner
Arturo Nahum
Duncan Evans
Alec Ee

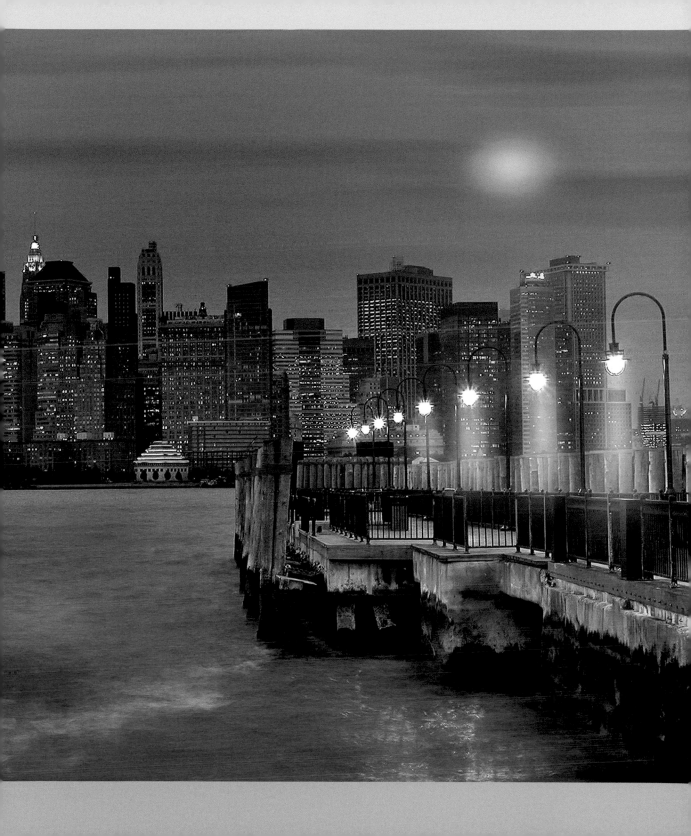

1/ Digital capture can often mean dull, flat colours and weak lighting, which need to be adjusted.

2/ The image was produced in Photoshop CS RAW converter.

3/ Digital noise was reduced.

# still life

This is one subject that isn't just for painters with a spare bowl of fruit. The still life genre is just as valid for the digital photographer, particularly as the scene can be lit with regular tungsten lamps rather than flash. In fact, it's an advantage to use tungsten because you can accurately position the light and control the shadows. Also, it adds a warmth that you don't get from flash.

## shoot

Arturo Nahum of Santiago, Chile, used a Nikon digital compact camera to shoot this image. He owns a small beach house in Zapallar, which has been in the family for more than 60 years. Old objects are in abundance, such as the ones in this picture. At night, Arturo often has the impulse to do some photography, so he rounds up objects to create still life pictures. The light came from a solitary tungsten bulb.

## enhance

The picture was shot in Nikon's Raw NEF format. Arturo used the Photoshop CS RAW converter to produce the image. He adjusted the white balance, exposure, contrast and saturation until he reached the desired result (2).

He then assigned an aggressive sharpening value (100) and also adjusted the Luminance and Noise Reduction to the values shown (3).

The Crop tool was used to tighten up the composition.

Curves was adjusted to enhance the contrast and saturation (4).

The Elliptical Marquee tool was used to select the area that he wanted to stay light. Transform Selection was selected. Next, the Marquee was moved into the exact position required (5).

The selection was inverted and then feathered by 200 pixels to give a very soft edge. The Curves tool was used again to darken the inverted section around the edge of the picture (6).

Finally, the Canvas Size option was used to create the frame.

> digital capture

> RAW conversion

> crop

> curves

> selection

> invert

> feather

> curves

> canvas size

**3  RAW sharpen**

**2  RAW converter**

4/ Contrast and saturation were enhanced.

5/ The Elliptical Marquee tool was used to select certain areas of the image.

6/ The selection was inverted and feathered.

7/ With processing of the RAW file, the colour and light are developed exactly as wanted.

**4  curves**

## 5  elliptical marquee

## 6  curves

Channel: RGB

OK
Reset
Load...
Save...
Smooth
Auto
Options...

Input: 62
Output: 53

☑ Preview

## enjoy

While the Nikon camera does not have a choice of colour space, Arturo sticks to the sRGB colour profile to prevent problems later on.

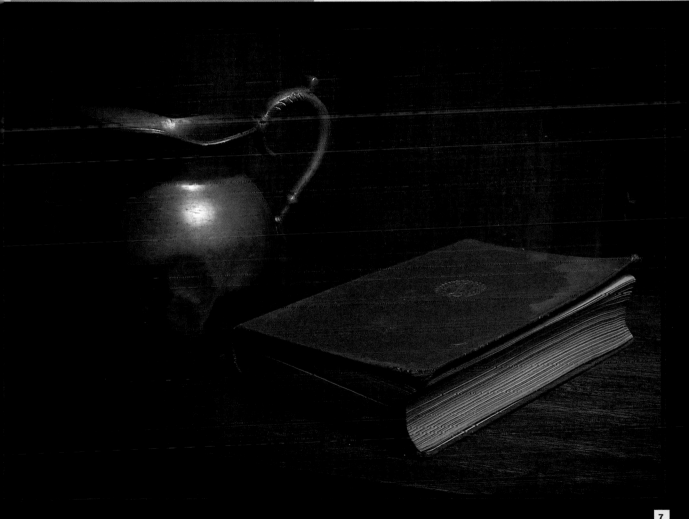

7

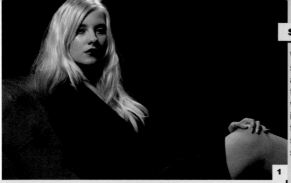

While images like these are possible to shoot with modern flash, tungsten will allow you to move lights around until the shadows and highlights are exactly where you want them to be. For this image, the main light was placed left of the camera, 45 degrees above the subject, to produce a downward shadow from the nose. This is typical of the 1930s and is called 'loop lighting'. There was a second light on the right, slightly behind the subject, to illuminate the hair and a third spotlight, above, to catch the edge of the top of the model's hair. The image was shot with a Fuji digital SLR and a Sigma short telephoto lens.

# classic portraits

In the 1930s and 1940s, the actors and actresses were photographed on set for promotional shots. These publicity shots were created using large tungsten lamps that would pour out direct and very hot light. Photographs were shot on very large plates and skilled retouchers would draw, etch and erase away to improve the appeal of the studio's asset. Modern digital equipment and lights can be used to create similar effects, harking back to the days of classic Hollywood portraits.

**enhance**

The first task was to change the colour photo to monochrome. This was done by using the Channel Mixer, ticking the Monochrome box and entering values of Red: 60%, Green: 10% and Blue: 30%. This produced a good range of monochromatic tones, with the skin tones being the brightest (2).

**2 channel mixer**

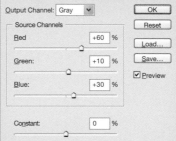

The layers were flattened and the Clone brush used to erase loose hairs (7).

**3 clone stamp**

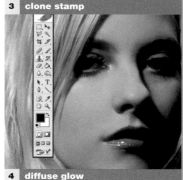

The Clone Stamp tool was then selected with a feathered brush, Opacity set to 20% and the Normal blend mode. By careful sampling the skin textures and small blemishes were smoothed over (3).

The Crop tool was used to change the picture into a portrait orientation, to concentrate on the hair and face.

The image was then interpolated to make it a more usable size. The vertical resolution was increased to 3024 pixels (4).

A duplicate layer was created and the Diffuse Glow filter run on it. The settings were Graininess: 0%, Glow Amount: 2 and Clear Amount: 15 (5).

A new Levels adjustment layer was then created in the Layers palette, with the mid-point of the level moving to the right to darken the chaise longue. The paintbrush was selected with a black foreground and the subject was masked off so that she appeared brighter again, leaving the background and furniture in the dark (6).

**4 diffuse glow**

**5 levels layer**

**enjoy**

The image was converted to CMYK for use in this book, which fortunately didn't affect it unduly as it is black and white. The image was originally shot for Yvonne McKay's modelling portfolio (www.yvonnemckay.co.uk). It was written to CD as a hi-res TIFF and also converted to a lo-res JPEG for use on websites and for sending by e-mail.

> digital capture
> channel mixer
> clone stamp
> crop
> image size
> duplicate layer
> diffuse glow filter
> levels adjustment layer
> clone stamp

! As modern tungsten lamps are quite low-powered, it is best to use a tripod with this kind of shot to avoid camera shake.

**6  clone stamp**

! Use accessories on lamps, such as barn doors and snoots, to control and direct the flow of light.

**1/** Shot using three tungsten lamps, this set-up was captured digitally, but required further image editing to achieve the desired effect.

**2/** Channel Mixer was used to produce a good range of monochromatic tones.

**3/** Blemishes were smoothed over.

**4/** The image was interpolated.

**5/** A new layer was created and Diffuse Glow was run.

**6/** Some areas were darkened.

**7/** With some tweaking to the overall lighting and cleaning up work, the picture now resembles one from the golden age of studio portraits.

**7**

**!** No filters should be required as the lights should be within the same brightness range as the background. Check the LCD playback. If the lamps have burnt out, dial in −0.5 or −1 EV exposure compensation and reshoot.

**!** For background interest a good depth of field is required. In these lighting conditions, shooting at f16 will require a tripod.

**2 crop**

# lamplight in the evening

At twilight the sky is full of colour from the sunset and yet it's dark enough for street lights. If you can find ornate street lamps, shoot pictures to capture both the residual light from the sky and the artificial light from the lamps – you're then well on the way to creating a dramatic, mixed-lighting shot.

## shoot

Alec Ee of Singapore shot this image on a September evening at Long Beach, Los Angeles, USA. He used a Sony compact digital camera with a 5x optical zoom at the wide-angle end. The light from the lamps and the evening sky were both within the exposure latitude of the camera so all Alec had to do was use zone metering to capture both.

## enhance

The original image was cropped to a square format to get rid of the space at the top of the picture (2).

The Curves function was used to darken the foreground objects so that they appeared as silhouettes. This added contrast to the sky, revealing more colour and brightening the highlights of the lamps. This gave the lamps a special glow (3).

Lastly, the Unsharp Mask filter was used with a low setting of 25% to add sharpness to the image without introducing too much digital noise (4).

**3 curves**

**4 unsharp mask**

**1/** The original image is a little flat, but the exposure is perfect for retaining detail in the lights and the sky.

**2/** The picture was given a square format.

**3/** Foreground objects were darkened using Curves.

**4/** THe Unsharp Mask filter was applied to improve sharpness without adding noise.

**5/** With some tweaks to brightness and contrast, along with a crop to the square image, the scene is now complete.

## enjoy

Alec makes 19 x 13 inch prints with Pictorico Photo Gallery high-gloss white film for use in exhibitions and sells them online at www.photo4me.com. He generally uses the sRGB colour workspace as it is faster to work with and is more accurate across devices.

> digital capture
> crop
> curves
> unsharp mask

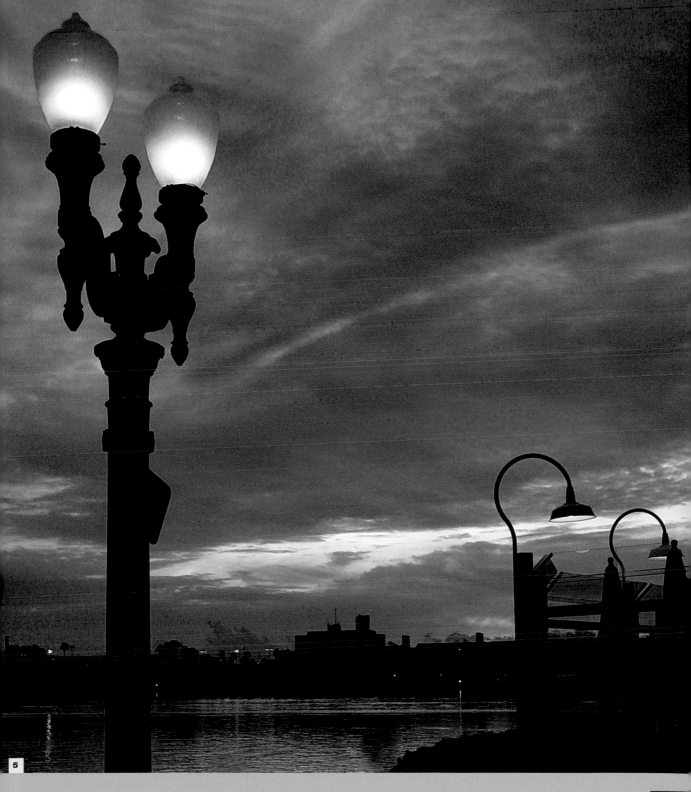

Professional tungsten lamps are brighter than household lamps, but still give off a colour cast. If shooting in colour, set your white balance manually; if shooting in black and white, this becomes irrelevant.

## 2  levels

**1/** The original image is dull and underexposed, but the composition is good and the lighting shadows are in the right places.

**2/** Levels was used to brighten the image.

**3/** The image was converted to monochrome.

# portraits on location

Shooting at a particular location can add ambience to an image. When you use tungsten lamps, you can see where the shadows go before you shoot and adjust them accordingly. Ideal locations range from rooms in houses to restaurants and large, industrial spaces. All can add meaning and drama to an image – just remember to match the lighting and styling so that they correspond to the background.

## shoot

This shot was a throwback to the studio portraiture of the 1940s, in which stars were often shot on the set, or just off it, with a plethora of props visible. In this picture there is a key light above and in front of the subject to produce the distinct butterfly shadow under the nose – a stylistic motif of this photography. A hair light was hung over the head of the subject, but unfortunately, no fitment was available to direct the light. As a result, the image is slightly wide ranging and unfocused, making the floor a little too bright.

## enhance

As the image was underexposed, a Levels adjustment layer was created in the Layers palette. The image was brightened until detail in the shirt started to disappear. Next, the paintbrush was selected with black paint at 20% and the detail brushed back into the shirt (2).

## 3  channel mixer

Output Channel: Gray

Source Channels

Red: 40 %
Green: 20 %
Blue: 40 %

Constant: 0 %

☑ Monochrome

OK
Reset
Load...
Save...
☑ Preview

## 4  layer blend

Soft Light   Opacity: 80%
Lock:   Fill: 100%

Background copy
Background

The subject's right hand was also painted on the mask of the adjustment layer, then the layers were merged. Next, the Channel Mixer was run to convert the image to monochrome. The settings Red: 40%, Green: 20% and Blue: 40% were used (3).

A duplicate layer was created in the Layers palette and the blend mode set to Soft Light. The Opacity was set to 80%. This gave a much darker image, while retaining the highlights (4).

A selection was then made around the face and down the chest, representing the plane of focus of the camera. This was feathered by 30 pixels, then the selection was inverted to select the background. The Gaussian Blur filter was run at 3-pixel strength to soften the background and represent a shallower depth of field. The layers were flattened (5).

A selection was then made with the Freehand Lasso tool around the subject, including part of the floor. This was smoothed by 5 pixels, then feathered by 50 pixels. The selection

## 5  gaussian blur

OK
Cancel
☑ Preview

33%
Radius: 3 pixels

## 6  new layer

Normal   Opacity: 100%
Lock:   Fill: 100%

Layer 1
Background

**4/** The image was darkened whilst retaining highlights.

**5/** The Gaussian Blur filter softened the background.

**6/** A new layer was created.

**7/** Highlights were held in place while the bottom of the image was darkened using Curves.

**8/** With conversion to black and white and the contrast boosted, the image now resembles the original vision.

## 7  curves

was inverted and the area copied and pasted as a new layer (6).

With the cut-out layer selected, the Curves function was run. The highlights were held in place with a control point, while a second was used to darken the bottom of the picture (7).

Finally, the Crop tool was used to tighten up the composition.

## enjoy

This shot was also resized for Web use as it was a joint project with Keith, the model, for his portfolio. The image was converted to CMYK for this book and a web-sized version was used on my website.

8

# 11 special digital processes

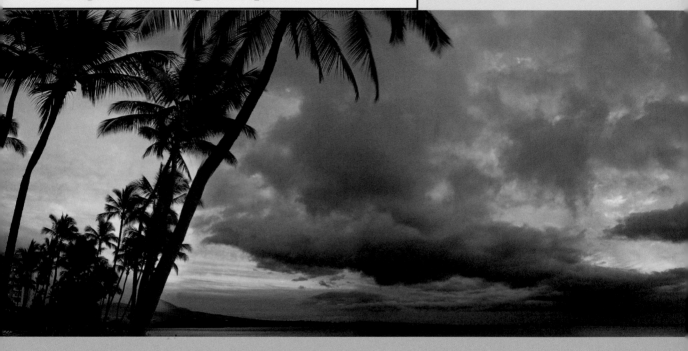

The advantages of digital are numerous. It ranges from straightforward correction, to noise reduction and enhancement, to full-scale creation and composition. Being able to construct panoramas or turn a digital colour image into a black-and-white one with exactly the tonal range desired makes it invaluable and exciting at the same time.

Oksana Pashko constructed this panoramic image from three pictures shot with her Canon compact digital camera, fitted with a Cokin Blue-yellow filter. It was shot in Hawaii, on the last day of her vacation there.

Oksana says, 'Three images were stitched together in Photoshop to make a panoramic photo. Level correction and colour enhancement were used to restore the original colour.'

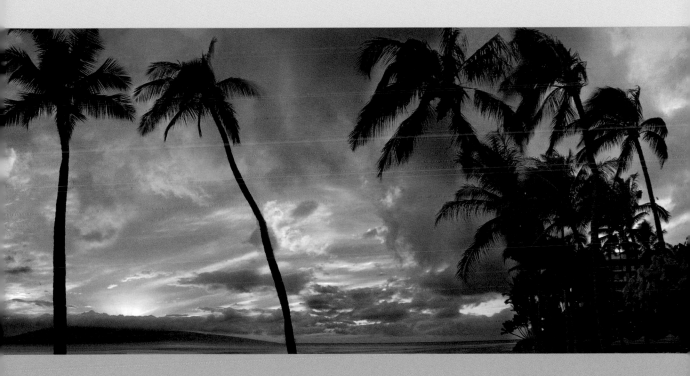

**photographers**

Oksana Pashko
Arthur Sevestre
Howard Dion
Sean McHugh
Arturo Nahum
Catherine Schultz

! Although this involves a good deal of image-editing, it helps if you get the composition of the image right in the first place. Ensure the original photograph is as good as you can make it.

**2** channel mixer

# advanced manipulation

This involves shooting under extreme lighting conditions and digitally manipulating the image so that it resembles a work of art rather than a straight photograph. The advantage of such manipulation is that you can create effects, looks and styles that are simply impossible to achieve with pure photography.

## shoot

This image was a combination effort from Arthur Sevestre, who took the photograph and Catherine Schultz, who performed the image manipulation. Arthur shot it with a Minolta SLR using a Sigma 24–70mm EX lens. The image gives the impression that the subject is toying with the dangerous idea of getting too close to the flame.

## enhance

The scanned slide was converted to black and white using the Channel Mixer in Adobe Photoshop (roughly 30% Red and 70% Green channel in monochrome) (2).

**3** hue saturation

**4** cloud filter

The black-and-white image was then toned using the colorize option in the Hue/Saturation tool in Photoshop. It was given a slight sepia toning (3).

A separate black layer was created. The Clouds filter in Photoshop was applied, then a lighting effect was added to create a highlight in the clouds around the candle. The layer was then toned sepia and placed behind the layer with the photo. The blending mode for the layer with the photo was set to Soft Light (4).

After this, a layer mask was added to the new layer. This makes it possible to erase parts of the layer using a black brush, and to retrieve the deleted parts using a white brush. The clouds directly underneath the model and candle were mostly removed using a black brush (5).

Many different brushes (with various types, opacities and sizes) were used to alter the cloud layer until it looked just right. All this produces a dreamier and more romantic effect (6).

**5** layer mask

**6** brush tool

> film capture
> scanning
> channel mixer
> hue/saturation
> clouds filter
> sepia toning
> layer mask
> brushwork

## enjoy

Both contributors prefer to use
Adobe RGB because of the wider
colour gamut. Arthur Sevestre's
speciality is nature photography,
but he thinks that portrait
photography also has its special
qualities. He has had several
images published in other AVA
book titles and has held two
exhibitions on nature photography.

The first was in the National
Museum of Natural History in
Leiden in the Netherlands. The
second was in the Portree Library
on the Isle of Skye.

1/ The starting point
for this project was
a very red-orange
image due to the low
light level.

2/ The scanned slide
was converted to
monochrome.

3/ A sepia tone was
added.

4/ The Cloud filter was
an added effect.

5/ A layer mask was
added to erase and
retrieve parts of the
image.

6/ Various brushes
were used to alter the
cloud layer.

7/ With substantial
digital editing, Arthur
Sevestre and
Catherine Schultz have
created a romantic
and atmospheric
image.

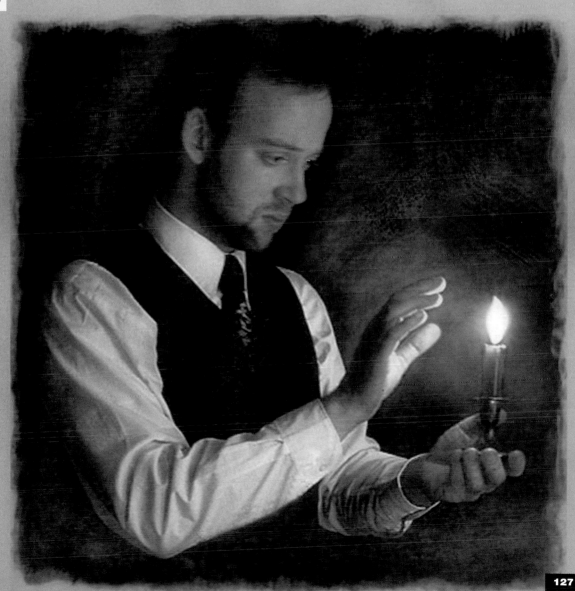

7

**!** Flash is not recommended for shots like these, so you need to get a fast enough shutter speed without drawing attention to yourself. A high ISO rating is usually required.

**2  greyscale conversion**

# black and white

**3  shadow highlight**

Shadows
Amount: 25 %
Tonal Width: 50 %
Radius: 30 px

Highlights
Amount: 0 %
Tonal Width: 50 %
Radius: 30 px

Adjustments
Brightness: -11
Midtone Contrast: +11
Black Clip: 0.01 %  White Clip: 0.01 %

Save As Defaults
☑ Show More Options

OK  Reset  Load...  Save...
☑ Preview

Digital is entirely suited to black-and-white photography because the original image captured is actually monochrome – the colour information is added afterwards. The camera records brightness levels then adds – and in most cameras, interpolates – the colour information from the colour matrix that overlays the CCD. In difficult lighting conditions, the colour image can be flat and lack any kind of impact, whereas once converted to black and white, all the texture and detail can be brought out.

## shoot

This image from Howard Dion is part of a storybook project he is working on. This picture was shot inside a coffee shop with very dim tungsten lighting. In addition, the window in the background was flooding the room with natural light from an overcast, but bright day. Here, the bright exterior light wasn't ideal as it could render the subjects as silhouettes, or make them

so dark, that computer enhancement would generate unacceptable noise levels. Howard focused on the bottle with the yellow cap and metered from there. The actual exposure was f3.5 at 1/125th of a sec so he could hold the camera surreptitiously and not attract the subjects' attention. To get an exposure that fast, he had to crank up the ISO to 400.

## enhance

To start, the image was cropped to get rid of the glaring white areas and provide a tighter composition on the subjects (2).

The image was converted to Greyscale, which stripped out the colour information but left the image looking bland and flat (3).

The Shadow/Highlight filter was used with settings of Shadow: 25%, Contrast: 11%, Brightness: -11% (4).

The Unsharp Mask filter sharpened up the detail with settings of Amount: 20%, Radius: 50, Threshold:0. This also altered the contrast slightly, and was remedied using the Curves tool (5).

Finally, a duplicate layer was created and the Find Edges filter used.

**4  unsharp mask**

OK  Reset  ☑ Preview

8%

Amount: 20 %
Radius: 50 pixels
Threshold: 0 levels

**5  layer blend**

The Layer Blend mode was set to Overlay at 25% to give extra impact and depth to the image (6).

> digital capture
> crop
> greyscale
> shadow/highlight
> unsharp mask
> curves
> duplicate layer
> find edges

For candid photography in public places, you do not need the subject's permission or a model release form. These shots work best when the subject is unaware of the camera.

## enjoy

Howard uses the sRGB colour mode as this offers the best calibration to his monitor and printer. He makes prints for competitions, gallery exhibitions and also sells prints to businesses. He works in both colour and in black and white. Howard believes that in photography, there are only two dimensions and the illusion of a third. Howard asserts that colour photography emphasises this illusion, whereas black-and-white photography does not. He decided that the latter was more appropriate for this image.

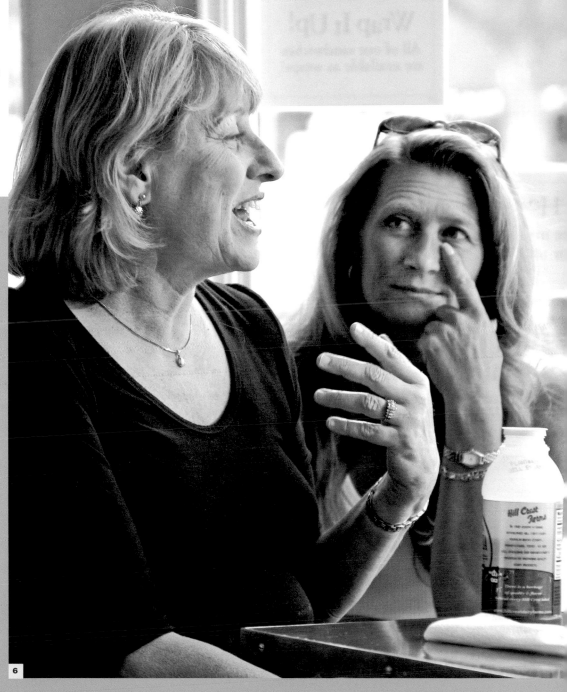

6

1/ Shooting backlit subjects in a café is a tricky shot, but Howard Dion succeeded admirably.

2/ The image was cropped for a tighter composition and converted to greyscale.

3/ The Shadow/Highlight filter was adjusted.

4/ Unsharp Mask was used to sharpen detail.

5/ The Layer Blend mode was set to Overlay for impact.

6/ After production work, the texture and detail in the black-and-white version of the image really stand out.

! Use centre-weighted or spot metering on the camera rather than zone; focus and meter on the skin tones of the main subject.

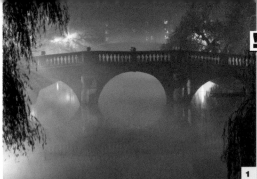

! Try to use the Histogram function on image playback to judge whether the image is properly exposed. If there are blank areas on the Histogram at either end, adjust the exposure and shoot again.

! Be careful when adjusting Hue/Saturation in low-light images – it can easily increase the digital noise to an unacceptable level.

! It's always worth taking an extra couple of pictures with manual white balance settings to see how they differ from the automatic reading. It's possible to get a picture with a more pleasing combination of colours this way.

# correcting white balance

Automatic white balance is a digital camera feature, which offers a hugely improved way of dealing with mixed or difficult lighting conditions compared to film. It is more prone to going wrong in low-light conditions, resulting in a colour cast. When it does go wrong, it's down to software to sort it out.

## shoot

This image of Clare Bridge in Cambridge, England, was taken by Sean McHugh using a Canon compact digital camera and a tripod. The bridge is the oldest across the Cam. This image was taken while peering from an opposing bridge on Garrett Hostel Lane, one late night in November. A cold fog was moving in and out so Sean waited until the clouds of fog were in position for the duration of the exposure.

**2  variations**

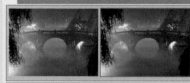
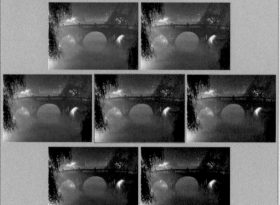

**3  levels**

## enhance

The main processing work on this image was to correct the significant green colour cast on the left side of the image. A duplicate layer was created and the Variations command used to add blue and cyan to the image to counter the green and orange colour casts (2).

The opacity of the duplicate layer was reduced until the effect blended in.

The noise levels in the image were reduced using the Neat Image plug-in, and then the contrast was increased using the Levels command (3).

Finally, the image was sharpened with the Unsharp Mask filter (4).

> digital capture
> duplicate layer
> hue/saturation
> Neat Image noise reduction
> unsharp mask
> resize for web
> sharpen for web

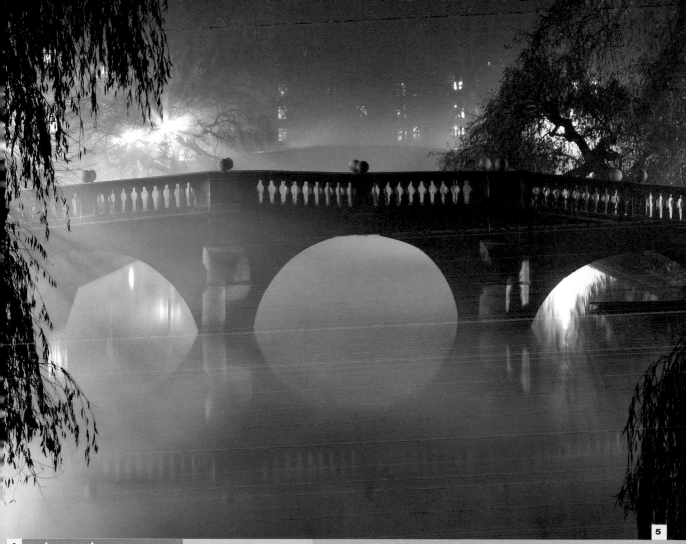

5 (top right corner)

## 4 unsharp mask

OK

Reset

☑ Preview

⊟ 100% ⊞

Amount: 50 %

Radius: 3.0 pixels

Threshold: 3 levels

**1/** The original image is excellent, but the white balance has given the lighting a significant green colour cast.

**2/** Green and orange colour casts were countered.

**3/** Noise levels in the image were reduced using Levels.

**4/** The image was sharpened using the Unsharp Mask filter.

**5/** Hue and saturation adjustments were required to minimise the cast and show how the image appeared to the naked eye.

## enjoy

Sean has a series of pictures showing the bridge under various lighting and atmospheric conditions. This one was an early attempt to photograph the bridge. Subsequent versions have sold well. Versions of this image were prepared for the Web by converting to sRGB, resizing to a smaller, appropriate resolution and sharpening to offset the softening that occurs through resizing.

# noise reduction

## shoot

One of the advantages of digital photography is that when the light levels are low, you can immediately switch to higher ISO ratings to keep the shutter speed up. However, the higher the ISO, the more digital noise appears in the photo. This is not like film grain from high ISO stock, but rather, random-coloured pixels because the sensor cannot accurately detect the light.

Norah Jones was playing in concert in Santiago, Chile, when Arturo Nahum, a resident of the city, took this shot. He was sitting about 100 feet from the stage, shooting with a Canon 8Mp digital SLR with a Canon EF 28–135mm f3.4 USM IS lens and the image stabiliser was switched on. Even so, it required an ISO of 1600 to get a shutter speed of 1/60th of a sec to overcome camera shake.

## enhance

The RAW conversion plug-in for the Canon camera was used to adjust the contrast significantly and set the colour temperature and colour cast (2).

Colour noise reduction options were used. This element of the plug-in reduces the amount of noise present in the image (3).

**2 contrast and colour**

**3 noise reduction**

**4 Noise Ninja**

The Noise Ninja professional noise reduction plug-in for Photoshop CS was used. This allows a luminance chart to be built, and areas that should not have any overt textures can be selected (4).

Having applied the noise reduction, the picture was then cropped to a more desirable shape, removing the empty space at the top and the distracting elements on the right (5).

**5**

> digital capture
> RAW conversion
> Noise Ninja plug-in
> crop

! When a high ISO is
required, consider
converting the image to
black and white.
The coloured noise will
then resemble grain
found in high ISO
black-and-white stock;
this will be far more
acceptable than
coloured noise.

! The effects of noise from high
ISOs differ from camera to
camera. Check yours out so that
you know whether the results will
be unacceptable. Avoid using
high ISOs whenever possible;
take a tripod, monopod or find
something flat to rest on.

**1/** Shooting from some distance
away, Arturo Nahum needed an ISO
1600 setting to avoid camera shake.

**2/** Contrast and colour were adjusted.

**3/** A noise reduction filter was used.

**4/** A luminance chart was built in
Noise Ninja professional.

**5/** With the use of the initial
RAW converter and a professional
noise-reduction program, this
ISO 1600 image has been
cleaned up superbly.

Arturo normally uses the sRGB colour
space as most of his photos are used
on websites. He usually shoots in RAW
mode to take advantage of RAW
conversion software facilities. Images
are resized and then sharpened before
being saved as JPEGs for uploading.
The original file is saved as a TIFF.

# appendix

Howard Dion of Bucks County, Pennsylvania, USA shot this image of a carnival worker taking a break, with a Tamron 28–65mm f2.8 XR Di short telephoto lens. It was after sunset and he had to ramp up the digital ISO to 800 to get a fast shutter speed.

Howard says, 'This image is included in my storybook project. It's a story about everyday people working, playing and being alone with their own thoughts. The majority of the subjects in the images were unaware that they were being photographed.'

# glossary

**Adobe RGB 1998:** Colour profile based on the RGB system with a wide colour gamut suitable for photographic images. See sRGB.

**Aperture:** The opening to a camera's lens that allows light into the camera to strike the CCD. See f-stop.

**Aperture priority:** Camera shooting mode. Allows the user to set the camera's aperture (f-stop) while the camera calculates the optimum exposure time.

**Artefact:** Minor damage or fault on a photograph, usually caused by JPEG file compression.

**Automatic white balance:** System within a digital camera that removes colour casts in images caused by the hues of different types of light.

**Bit:** Binary digit. Smallest unit of information used by computers.

**Bitmap:** Digital image made of a grid of colour or greyscale pixels.

**Byte:** A string of eight bits. 1024 bytes make a kilobyte (KB), and 1024KB make a megabyte (MB).

**CCD (Charge Coupled Device):** Electronic device that captures light waves and converts them into electrical signals.

**CD-R:** A compact disc that data can be written to but not erased.

**CD-RW:** CD-RWs can be erased and used a number of times.

**Chromatic aberration:** Colours bordering backlit objects. Caused by the poor-quality lens systems used in many compact cameras. Can also affect high-quality optical systems, but only to a limited degree.

**CMOS (Complementary Metal Oxide Semiconductor):** A light-sensitive chip used in some digital cameras and scanners instead of CCDs. CMOS chips are cheaper to develop and manufacture than CCD chips, but they tend to produce softer images.

**CMYK:** Abbreviation for cyan, magenta, yellow and black – the secondary colours from which colours can be derived. CMYK is used to reproduce colours on the printed page and has a narrower gamut than RGB. See RGB.

**CompactFlash:** Type of memory card with the interface built in.

**Compression:** Process that reduces a file's size. Lossy compression systems reduce the quality of the file. Lossless compression does not damage an image. See JPEG.

**Digital image:** A picture made up of pixels and recorded as data.

**Digital zoom:** Process that simulates the effect of a zoom by cropping photos and enlarging the remaining image. Reduces image size. See Interpolation and Zoom lens.

**Download:** Process of transferring data from one source to another, typically a camera to a computer.

**DPI (Dots Per Inch):** Measurement of print density that defines the image size when printed, not its resolution.

**DVD (Digital Versatile Disc):** High capacity storage medium like CD, but offering six times the space.

**DVD-R:** Most common type of recordable DVD disc. While multi-session compatible, data cannot be erased.

**DVD-RW and DVD+RW:** Erasable and re-recordable versions of DVD.

**Dynamic range:** The range of the lightest to the darkest areas in a scene that a CCD can distinguish. Also known as exposure latitude.

**Electronic viewfinder:** A small LCD display that replaces optical viewfinders in some digital cameras.

**EXIF (Exchangeable Image File):** Shooting data recorded along with the picture by a digital camera.

**Exposure compensation:** Adjustment applied to a photograph to correct exposure, without adjusting the aperture or shutter speed.

**Exposure value (EV):** Measurement of a photograph's brightness.

**f-stop:** A camera's aperture setting. A high f-stop number means the camera is using a narrow aperture.

**File size:** A file's size is determined by the amount of data it contains.

**Image-editing software:** Program used to manipulate digital images. Also known as image-processing, image-manipulation, photo-editing or imaging software.

Shot with a Canon consumer digital SLR, this image by Tiago Estima of Lisbon, Portugal shows the effect of bright, reflective water by throwing the subject into silhouette.

**Image resolution:** Number of pixels stored in a digital image.

**GIF (Graphic Interchange File):.** Common internet graphic format, used for banners and icons where few colours are required.

**Ink-jet printer:** Printer that sprays fine dots of ink on to paper to produce prints.

**Interpolation:** A process to increase an image's resolution by adding new pixels. This can reduce image quality.

**JPEG (or JPG):** File format that reduces a digital image's file size at the expense of image quality.

**K/s:** Kilobyte per second. A measurement of data transfer rates.

**Kilobyte (K or KB):** Unit of computer memory. Equal to 1024 bytes.

**LAB colour:** Colour mode consisting of a lightness channel and two colour channels, A covering green to red, and B covering blue to yellow colours.

**Laser printer:** Printers that print documents by fusing toner or carbon powder on to paper surface.

**LCD (Liquid Crystal Display):** A small light display. Lit by running a current through an electrically reactive substance held between two electrodes.

**LCD monitor:** A small, colour display built into most digital cameras. Allows the user to preview/review digital photos as they are taken.

**Lithium-ion (or Li-ion):** Powerful rechargeable batteries. Not affected by the memory effect. See Ni-Cd.

**MAh (Milliamp Hours):** A unit of measure to describe a battery's power capacity.

**Mb/s:** Megabyte per second. A measurement of data transfer rates.

**Megabyte (Mb or MB):** Unit of computer memory. Equal to 1024 kilobytes.

**Megapixel (Mp):** A million pixels. A standard term of reference for digital cameras. Multiply the maximum horizontal and vertical resolutions of the camera output and express in terms of millions of pixels. Hence a camera producing a 2400 x 1600 picture would be a 3.8Mp camera.

**Memory effect:** The decrease of a rechargeable battery's power capacity over time.

**Memory Stick:** Sony's proprietary solid state storage media.

**Microsoft Windows 2000:** A Windows NT-based system used for businesses.

**Microsoft Windows 98/Me:** Home-user operating system used on PCs. Now superseded by Windows XP.

**Microsoft Windows NT:** The Microsoft operating system designed for businesses using more secure file handling and access. Now outdated.

**Microsoft Windows XP Home:** The current direction of Windows. This version is based on the NT kernel, but designed for home users.

**Microsoft Windows XP Professional:** Version of XP for home users, professionals or small businesses.

**Microdrive:** A miniature hard drive offering large storage capacities that can be used in digital cameras with a CompactFlash Type II slot.

**MultiMedia card:** Type of storage media used in digital devices.

**Neutral density filter:** One that reduces the light coming into the camera for creative purposes. A graduated ND filter progresses from grey to white, so affects only the top or bottom of the image.

**Ni-Cd or Nicad (Nickel Cadmium):** Basic type of rechargeable battery. Can last up to 1,000 charges, but can suffer from the memory effect. See Memory effect.

**NiMH (Nickel Metal Hydride):** A rechargeable battery. Contains twice the power of similar Nicad batteries. Also much less affected by the memory effect. See Memory effect.

**Optical viewfinder:** Viewfinder that delivers image of the scene either directly, or via mirrors, to the user, without recourse to electronics or an LCD.

**Outputting:** Process of printing an image or configuring an image for display on the Internet.

**PC card:** Expansion card interface, commonly used on laptop computers. A variety of PC cards offer everything from network interfaces, modems and holders for digital camera memory cards. Some memory card readers use PC card slots (or PCMCIA cards).

**PC sync:** A socket on a camera that allows the camera to control studio flash systems.

**Pen tablet:** Input device that replaces a mouse. Moving a pen over a specially designed tablet controls the cursor.

**Photoshop:** Industry-standard image-manipulation program produced by Adobe.

**Pixel:** A tiny square of digital data. The basis of all digital images.

**Pixellation:** The effect when individual pixels can be seen.

**Plug-in:** Software that integrates with a main photo-editing package to offer further functionality.

**PNG (Portable Network Graphics):**. A file format commonly used for images used on the internet. Can be defined in anything from 8-bit to 48-bit colour.

**Polariser filter:** Blocks light waves at a specific orientation. Used to enhance skies and reflections, or block reflections.

**Printer resolution:** The density of the ink dots that a printer lays on paper to produce images. Usually expressed as dpi (dots per inch), but note that this is not the same thing as the ppi (pixels per inch) of an image.

**RAW:** This file format will record exactly what a camera's CCD/CMOS chip sees. The data will not be altered by the camera's firmware (images are not sharpened, colour saturation is not increased, and noise levels will not be reduced).

**RGB:** Additive system of colour filtration. Uses the combinations of red, green and blue to recreate colours. Standard system in digital images. See CMYK.

**Secure Data (SD):** A type of solid-state storage medium used in some digital cameras.

**Shutter priority:** Camera shooting mode. The user sets the camera's shutter speed, while the camera calculates the aperture setting.

**SLR (Single Lens Reflex):** This camera has the advantage that the image it shows through the optical viewfinder is the one that the camera sees through the lens. Digital SLRs are much faster, more responsive and more powerful than compact digital cameras.

**SmartMedia:** A type of storage card used to store digital images. Very popular digital camera format, now replaced by x-D Picture Card format.

**sRGB:** Common, but limited, colour gamut profile of the RGB system. Most commonly used in digital cameras. See AdobeRGB.

**Thumbnail:** A small version of an image used for identifying, displaying and cataloguing images.

**TIFF:** Image file format. Used to store high-quality images. Can use a lossless compression system to reduce file size, without causing a reduction in the quality of the image. Available on some digital cameras as an alternative to saving images using the JPEG format.

**TTL (Through The Lens) metering:** A sensor built into a camera's body that uses light coming through the lens to set the exposure.

**USB 1.1 (Universal Serial Bus v1.1):** External computer to peripheral connection that supports data transfer rates of 1.5Mb/s. One USB 1.1 port can be connected to 127 peripherals.

**USB 2.0 (Hi-speed USB):** A variant of USB 1.1. Supports data connection rates of up to 60Mb/s. USB 2.0 devices can be used with USB 1.1 sockets (at a much reduced speed), and USB 1.1 devices can be used in USB 2.0 sockets.

**VideoCD:** The forerunner to the DVD video format. Lower resolution than DVD video but is used with standard CDs. Can be played on PCs.

**WYSIWYG:** Acronym of 'what you see is what you get'. A term for a computer interface that outputs exactly what is seen on screen.

**xD-Picture Card (xD Card):** Memory card format that has been developed by Toshiba, Fujifilm and Olympus. Designed as a replacement for SmartMedia.

**X-sync:** The fastest shutter speed at which a camera can synchronise with an electronic flash.

**Zoom lens (Optical zoom):** A variable focal length lens found on most cameras. Used to enlarge images. See Digital zoom.

Mr Sun by Marcio Cabral.

# contacts

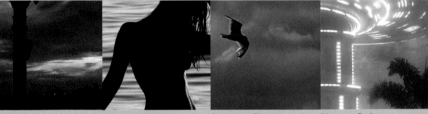

### Jeff T. Alu

Jeff Alu of Orange, California, USA, looks for strong contrast in his photos. He only uses the inexpensive 'point and shoot' digital cameras in his work. He likes to travel lightly, and finds that he can make up for any shortcomings in the camera via processing in Photoshop. It is not his goal to take perfect photos, but to communicate with the viewer the feelings he felt at the time of shooting.

**Page 32**
**animalu.com**

### Nina Indset Andersen

Nina Andersen from Oslo, Norway, is 35 years old and has loved photography for about six years. Today, she works as a freelance photographer for Scanpix Creative, Norway's largest stock photo agency. She has invested in a Canon 1Ds mark II to get the best quality and resolution out of her pictures. She mostly shoots portraits and people photography, but also does scenery and macro pictures when the opportunity arises.

**Page 90**
**eyesondesign.net**

### Peter Anderson

Peter Anderson from Orlando, Florida, USA, purchased his first digital camera at the beginning of 2000 and has been getting reacquainted with the art of photography ever since. He is amazed at how differently he views the world now. Peter maintains a website called Photoquotes on which he publishes weekly religious photo cards and photo essays.

**Page 26**
**home.cfl.rr.com/**
**maarigard**

### Deryk Baumgaertner

Deryk Baumgaertner of Cologne, Germany, started taking pictures when he was 14 with a Canon AE-1 program. At the time, he also had his own black-and-white lab. With the digital era he discovered his love for night photography. He says, 'When most people are still in bed, I am somewhere outside capturing the beauty of the night.'

**Pages 10, 14, 114**
**outdoor-**
**photography.net**

### Alec Ee

After two years participating in the top photo website, www.photo.net, Alec Ee's portfolio has had more than 10.8 million hits and is currently fourth for photographer's ratings out of 270,000 registered members. He uses 13 x 19 inch prints on Professional Pictorico film to exhibit his work in overseas ventures and trade shows. Apart from contributing to digital photography magazines, his images have also been used on book covers.

**Page 120**
**www.elanist.com/alec**

### Tiago Estima

Tiago Estima is a 26-year-old software engineer living in Lisbon, Portugal. He has been interested in photography for some years now, starting with film then moving on to digital photography. He likes to discover interesting perspectives in relatively common scenarios and create images from little details. Nowadays, he is more interested in landscape and people. He tries to maintain some aesthetic coherency in all his work.

**Page 136**
**estima.home.sapo.pt**

### Duncan Evans LRPS

The author of this book, Duncan is a writer and photographer. He is an expert in digital photography, having been the Editor of *Digital Photo User* and its successor for nearly five years. He is also a member of the Royal Photographic Society, with a Licentiateship distinction. As well, he is a member of the Digit digital imaging group and has had photos published in books, magazines and the national press.

**Pages 42, 47, 48, 58, 70, 79, 118, 122**
**duncanevans.co.uk**

### Kenny Goh

Kenny Goh, of Kuala Lumpur, Malaysia, uses photography to capture the essence of beauty and maintains that it exists even in the most unlikely setting. He has been into photography for five years now and his Canon EOS 10D digital SLR now goes with him everywhere.

**Page 62**
**kenjiimages.net**

### Jon Bower

Jon Bower is currently juggling careers as a freelance photographer, environmental consultant and writer. Jon has been photographing people, places and landscapes all over the world for the past 25 years. He also contributes to several well-known image libraries including Alamy and Ecoscene. Jon describes his photography as eclectic and pragmatic.

**Pages 24, 92, 96**
apexphotos.com

### Márcio Cabral

Márcio Cabral lives in Brazil and has been taking pictures for about seven years. He prefers to photograph landscapes and has started to use digital cameras as they offer more resources and allow better results in a shorter period of time. He tries to keep up to date by studying and testing new techniques so that his work flow is always evolving.

**Page 4, 27, 52, 139**
pbase.com/
marciocabral

### Jorge Coimbra

Jorge Coimbra is 44 years old and works as an engineer. He is an amateur photographer. He used to be interested in photography as a teenager, but his enthusiasm was fired up again about five years ago when he bought his first digital compact camera. He prefers natural and humanised landscapes as subject matter.

**Page 50**
jorgecoimbra.home.
sapo.pt

### Paolo Corradini

Paolo Corradini of Perugia, Italy, treats photography not as his job, but as his biggest passion. He likes to capture atmosphere and subjects while projecting his feelings on to the images – and then realising that the observers find the same emotions in his pictures. He has had four personal exhibitions of his work in Italy.

**Page 83**
usefilm.com/artist/
paolocorradini

### Howard J. Dion

Howard's interest in photography started in 1995 and rekindled a creative drive that had been dormant since he attended the Pennsylvania Academy of Fine Arts in 1961 and 1962. Howard is self-taught and sees himself as a digital artist for the new millennium because he photographs, processes and prints 100% digitally. Howard currently lives with his wife Rebecca in Bucks County, Pennsylvania.

**Page 128, 134**
afterthoughts.
photopoints.com

### Dirck DuFlon

Dirck DuFlon of Clermont, Florida has been a photography enthusiast since he was about 12. His mother (a wonderful photographer in her own right) gave him his first real camera. Dirck believes there is beauty, pattern and wonderful detail everywhere. He enjoys finding interesting interpretations of everyday subjects, and trying to showcase the beauty in the mundane.

**Pages 18, 36, 104**
pbase.com/dirck

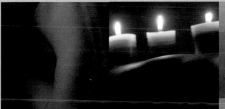   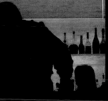 

### Eric Kellerman

A resident of Berg en Dal, in the Netherlands, Eric Kellerman started serious photography when he bought a Nikon D1 digital camera in 2000. He photographs almost exclusively with artificial light and also works entirely digitally. Eric's photographic aim is to dissociate the body from its overtly erotic or glamourous associations, and to reveal its sculptural qualities in abstract ways.

**Page 102**
erickellerman
photography.com

### Detlef Klahm

Detlef Klahm from Vancouver, Canada, has been an avid photographer for many years now and his approach to it has always been to try better, try something different and unique. The digital movement has given Detlef the chance to stretch his imagination as never before.

**Page 108**
paintwithlight.net

### Juergen Kollmorgen

Based in Guangzhou, China, Juergen Kollmorgen enjoys the advantages of digital photography. He has been using Sony cameras because of their outstanding infrared capabilities and superior optics. At the same time, he is a die-hard film user because of the large amount of digital information that can be extracted to make very large prints.

**Page 6**
lightandpaint.com

### Jeffrey Kubach

Jeffrey, from Los Angeles, can't really explain his approach to taking photos because it seems that his instincts play a bigger role than any formal training he has had. He will usually take photos when he feels a certain mood about the environment he's in. Jeff tries to capture the mood with lighting, colour and composition. Then, using Photoshop, he will correct the image to give it extra flavour and punch.

**Page 66**
betterphoto.com/gallery
/gallery.asp?mem=
71831

### Judi Liosatos

Judi Liosatos is a country-based Australian photographer who doesn't limit herself to just one area of photography. Advanced in both Adobe PS and Corel PSP, her work covers both photography and photo art. Her images have been used worldwide, and also adorn the walls of private homes. She is also called upon by newspapers to capture breaking news events. Her work has attracted many awards, both online and offline.

**Page 110**
judigraphics.com

### Marion Luijten

Marion Luijten, from Oisterwijk in the Netherlands, mainly works on macro floral work and travel photography. She also shoots images for her website, a shop and art sales site she runs with her daughter. Marion does almost all the product photography, although a few images come from the suppliers. She likes to work in Photoshop, though is still learning, and prints and frames her own work.

**Page 68, 98**
coloursofnature.com

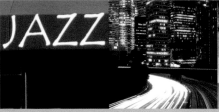
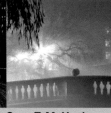

### Patricia Marroquin

A resident of Oxnard, California, Patricia Marroquin enjoys photographing colour, humour and beauty. She tries to find a different perspective for her images, such as photographing a sunset through a hammock. She shoots exclusively digital now with a Canon 20D. Although everybody preaches the importance of using a tripod, Patricia doesn't use one. She says maybe one day, when she gets older and very shaky.

**Page 34**
patriciapix.com

### Thomas McConville

Thomas's approach to photography is that if he can get a beautiful image without doing major editing, then he'll do it. In reality, however, he finds himself using Photoshop more and more these days to give him surreal and vivid images; the only limit being his imagination.

**Page 78**
theimagegroup1@
earthlink.net

### Sean T. McHugh

Sean McHugh's "Cambridge in Colour" collection was taken from in and around the University of Cambridge in the UK. The city's heritage of history and tradition makes it uniquely scenic. In low-light conditions, it comes alive with a moody atmosphere, full of charm and character. Sean uses long exposures during rare twilight or moonlit conditions, taking the viewer to magical places, which visitors seldom see.

**Pages 82, 130**
cambridgeincolour.com

### Kelly Munce

Kelly Munce of Australia is new to the wonderful world of photography. She finds it best to capture the moment by shooting everything that takes her eye. Since first picking up a camera in October 2004, she has won numerous photography awards, including second place in the McGregor Prize for Photography, University of South Queensland. Her main goal is to have fun and capture as many special moments of her children as possible.

**Page 86**
kellymunce
photography.com

### Arturo Nahum

Arturo Nahum, an amateur photographer from Chile, switched to his first digital camera (a 1.3Mp Olympus) at the age of 13. This moment changed his life. He says that digital can boost your learning curve, as the cost of making thousands of pictures is really low and results are seen almost immediately – so the process for learning is fast.

**Pages 116, 132**
anahum.photopoints.
com

### Eskil Olsen

Eskil Olsen lives in Skonseng in northern Norway. His main interest is photography and he has been photographing since the age of 12. Nowadays, he mostly uses his digital camera and he's currently exploring the potential of the digital darkroom. He likes nature photography best, but takes more and more portraits.

**Page 60**
eskilolsen.no

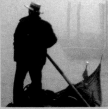
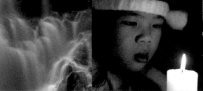
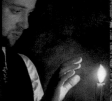

### Steven Rosen

Steven Rosen of Brooklyn, New York, has been a visual artist his entire life, making a living as an illustrator, jewellery designer and layout artist. He has always had an interest in photography, and it was the advent of digital cameras that made him a serious photographer. As a New Yorker, he spends a lot of time recording his incredibly vibrant city and its citizens. As an avid traveller, he tries to capture the thrill of new places and new people.

**Pages 12, 54, 56**
stevenrosendesign.com

### Keith Saint

Keith Saint of Ashington, England, enjoys doing landscape photography. He prefers early morning or night shots as he loves the way light influences scenes. When planning a shoot, he likes to know where the sun will be by using an ordnance survey map. He believes there is nothing worse than shooting into the shade when you need the light on the subject. He uses a Canon 20D, Sigma 15–30mm, Canon 18–55mm and Canon 70–20mm lenses.

**Page 80**
usefilm.com/
photographer/72835.
html

### Jean Schweitzer

Jean Schweitzer is a resident of Germany. He made his first picture sale in the USA in 2002. Shortly thereafter, he won the Hørsholm-Kommune Photo competition and was published in *Practical Photography* (UK). Since then he has won a Lexmark competition, been exhibited in Germany, and made the front cover of a magazine. He has also completed many photographic projects for communities and has been interviewed in the Italian magazine, *FotoComputer*.

**Page 112**
cliclac.dk

### Arthur Sevestre & Catherine Schultz

Arthur Sevestre of the Netherlands and Catherine Schultz of Canada collaborated on this image. Arthur says, "That one moment when the ordinary is transformed into the extraordinary, that is the moment I hope to capture. By sharing these, hopefully more eyes will open up to the spectacular world around us."

**Page 126**
artsevestre-
photography.com

catherineimages.com

### Mirko Sorak

Mirko was born in Zagreb, Croatia. After he finished high school, he started working in the automotive industry with photography as a hobby. After buying a digital compact in 2002, he started reading books and practising. He now owns a Canon EOS 10D with Sigma 18–50mm, Sigma 24–70mm, Sigma 105mm macro, Sigma 70–200mm and Canon 500D close-up lens. Mirko likes all types of photography, but macro is his favourite.

**Page 64**
mirko-sorak.com

### Chris Spracklen

Chris Spracklen of Somerset, England, enjoys landscape photography. He loves the creative freedom of manipulating his digital images in Photoshop and likes to think of himself more as a photoartist rather than a straightforward photographer. Chris is a church pastor and uses his images within his work. He incorporates them into PowerPoint presentations and makes cards, CD covers and posters.

**Page 22**
pbase.com/moorlands

 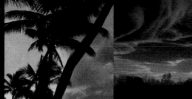 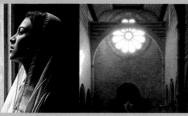

### Anupam Pal

Anupam Pal of the USA has been practising photography for the last 15 years. He shoots a variety of subjects ranging from nature, people, still life and sports. As a photographer, his main objective is to communicate. He tries to capture images that let the viewers feel what he felt when he saw the original scenes. He tries to capture images that tell stories with their simplicity.

**Page 106**
**pal-and-basu.com**

### Oksana Pashko

Oksana Pashko is a resident of the USA and uses a Canon PowerShot G3 with a range of filters – including the Cokin Blue/Yellow filter – to enhance the colours in her photographs.

**Page 124**
**betterphoto.com/**
**gallery/gallery.asp?**
**memberID=39105**

### Fernando Pegueroles

Fernando Pegueroles is an advanced amateur photographer based in Barcelona, Spain. He uses a Nikon D70 digital SLR camera. He has done two exhibitions and his photographs have been published in a local magazine and in two AVA photography books. He likes to make landscapes with special lighting, beautiful colours and a pleasant and peaceful mood.

**Page 44, 46**
**fpp1949@eresmas.com**

### Kenvin Pinardy

Kenvin Pinardy from Jakarta, Indonesia, became interested in photography when he bought a digital camera in February 2004. The digital era makes it easier for beginners to get to grips with photography. Initially, he took macro and still life photos. He now prefers to take human interest photos, and lately, images using models.

**Page 72**
**pinardy.com**

### Felipe Rodríguez

Felipe Rodriguez of Seville, Spain, counts himself as a digital photographer, even though he has an old film SLR camera. He always takes his digital camera and some lenses with him, in case an opportunity presents itself. Almost every time he looks at anything, he is composing a frame for a photograph.

**Pages cover, 74, 94**
**beatusille.net**

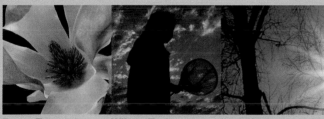 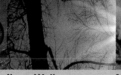 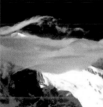 

### Roger Tan

Roger Tan lives in Guangzhou in China and started taking photos when he was nine. His first camera was the plastic 'Diana' toy camera. During school holidays, he would record his holiday memories in pictures. He uses a Sony Cybershot F-707 and F-828 – he appreciates the infrared capabilities and cost effectiveness. However, he believes a good photographer needs a good concept, composition and most of all, love and inspiration.

**Page 28, 100**
**lightandpaint.com**

### Wilson Tsoi

Photography has become the primary way for Wilson Tsoi of Mukilteo to express himself artistically. Wilson applies to his photography the fine and commercial art techniques he has learned and studied. He loves to find unique points-of-view, especially for images of often photographed places. Some people think that only expensive gear can yield artistic images, but he would be the first to disagree.

**Pages 76, 84, 88**
**photo.net/photos/wilson**
**tsoi**

### Ilona Wellmann

Ilona Wellmann of Gummersbach, Germany, focuses her attention on the field of fine art Photography. She has been a semi-professional photographer for the past four years. Many people say that digital photography is a manipulation of reality, but in her opinion, it is an open door to personal creativity.

**Page 38, 40**
**IlonaWellmann.**
**meinatelier.de**

### Martin Wierzbicki

Martin Wierzbicki is a travel photographer based in San Francisco, California. He has travelled through 50 countries and across six continents. Whether scuba diving in the Gulf of Thailand or high-altitude trekking in Nepal, Martin always has his camera close at hand. His photographs have appeared in numerous publications, including *National Geographic Adventure* magazine. Martin's photos and travel writing can be found on his website.

**Pages 16, 30**
**photosbymartin.com**

### Wayne Willis

Wayne Willis of Mount Gambier, Australia, feels that his photography is a gift from God and that it not only gives glory to God, but also shares the glory of God's creation with others. He prefers to concentrate on seascapes and macro but has done some sporting events. He likes the sense of moving water, the dynamic nature of the sea and doesn't mind getting wet, muddy and cold while in search of a perfect image.

**Page 20**

**photo.net/photodb/**
**member-photos?**
**user_id=574417**

# acknowledgements

I would like to thank a number of people for their invaluable assistance in the production of this book. Firstly, Brian Morris at AVA for making the project happen, and Renee Last for guiding it along. Sarah Jameson for picture research and dogged hounding of contributors for missing material. The contributors themselves who have supplied beautiful photographs for us to use – in particular, Howard Dion for his seemingly inexhaustible supply of great images and enthusiasm. Once more, I am indebted to Bruce Aiken for his clean, modern and stylish designs. I would also like to thank Laura Coombs and Renee at AVA for the seemingly endless task of downloading material from the server and sending it to me at the other end of the country. My thanks also go to Keith Morrell, the chap in the spread on classic portraits, who saved the day when the model failed to turn up at the studio. To everyone who has helped make the book come about, thank you one and all.

Duncan Evans LRPS
www.duncanevans.co.uk